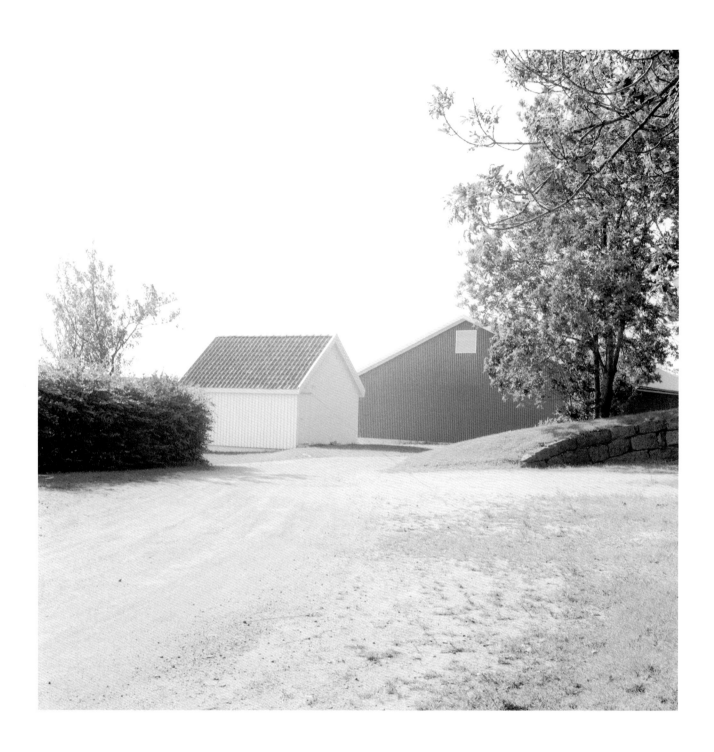

# DAG ALV GANG

ROBERT ADAMS | EVA KLERCK GANGE | THOMAS WESKI

FORLAGET OKTOBER

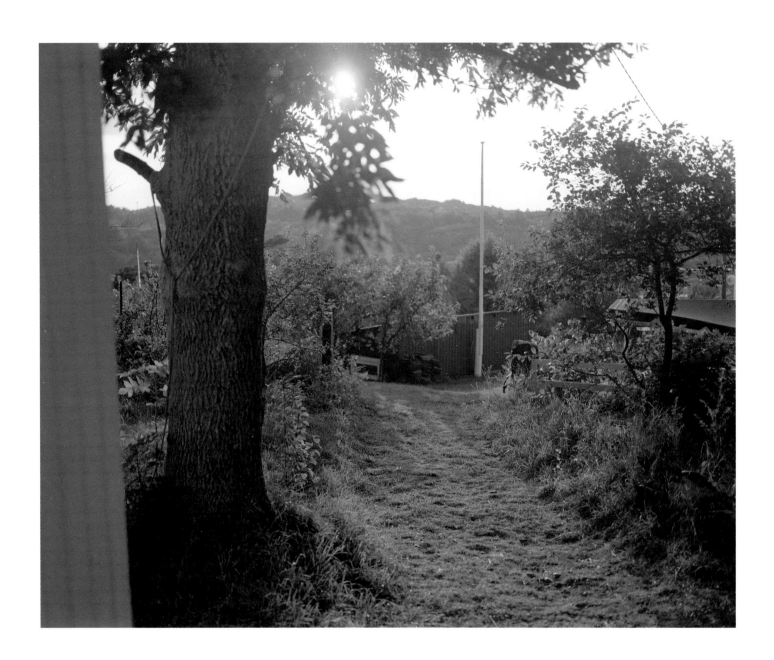

# Photography as an instrument of perception

ONE LAST ALL-EMCOMPASSING GLANCE and then it's «Bye-bye, lake! Bye-bye, wind! Bye-bye, garden!» That's how our five-year-old son Lennart takes his leave of our weekend cottage when Sunday evening comes around and it's time to drive back to our home in the city. The list may vary, but he never forgets it. Indeed, this repetition has become a ritual which helps to take the sorrow out of parting. By addressing each in turn, by name, Lennart seems to be reassuring himself about the specific characteristics of this country refuge, the environment with which he is in total harmony. Not only has the place become part and parcel of his life, but, by reason of the fact that it is not always available, our home in the country has also acquired a special meaning. His perception of the place is more intense, for it can never be taken for granted. Forever having to leave it behind, Lennart is constantly obliged to come to terms with it anew. Everything is familiar and strange at the same time. It's the feeling we all have when we return home from a long vacation and are able to see, hear, smell and feel familiar objects in a fresh way, discovering in them completely new and unexpected qualities. Photography, too, can convey such an experience. For me, one of the essential qualities of photography is its capacity to show us everyday life from an altogether different perspective. Indeed, it can be the very prerequisite for a broader perception of the world we live in. What characterizes the work of the Norwegian photographer Dag Alveng is not only this capacity to broaden our perception but also his ability to recognize the universal significance which just one small piece of reality can have for an individual.

Time and again, Alveng returns to the same house near the sea. There he photographs the building, its inhabitants and their guests, the path that leads down to the coast and, finally, the sea itself. But in just the same way as his landscape photographs are not purely topographical descriptions, Alveng's photographs of people are not conventional portraits. Various kinds of

photography converge in his images, and in a mixture which has a lasting effect on us, for they defy precise classification. They always have additional levels of meaning, but this quality is latent and only becomes visible on repeated viewings.

Dag Alveng uses an old 8 x 10 inch, large-format view camera. This enormous camera is roughly the size of a portable television set and cannot be used without a sturdy tripod. Since the individual sheets of film are loaded into unwieldy film holders the size of magazines, the number of photographs that can be taken at any one time is extremely limited. The reward for this rather difficult and involved method of taking photographs is a large-format negative which is packed with perfect detail. Contact prints made from these negatives, that is prints exactly the same size as the negatives, manifest the highest conceivable definition and precision. Indeed, the rendition of the subject is so compressed that enlargements have to be made from the negatives before we can fully read and appreciate their detail. When shown in exhibitions, the prints are enlarged to six times the size of the negatives. As a consequence, the prints no longer create a miniaturizing effect through their wealth of fine detail but, rather, operate as large-format photographs. We, the viewers, perceive the images in a completely different, physical way because of their size.

Photographs presented in this way have a strange attraction, making us look at them again and again, and more and more closely each time. We find ourselves constantly wanting to step back and view them in their entirety and then, no sooner have we changed our viewing position, we feel the inclination to step forward and examine them again for their detail. Indeed, these technically perfect black-and-white prints readily permit such detailed examination. Their color is the color of memory; our perception of their finely rendered gray tones anchors them – psychologically – in the past. The choice of black-and-white photography is one of the conceptual decisions made by the artist, for it has the immediate effect of abstracting reality. Color photography links the subject matter too much with the here and now. The absolute clarity of the black-and-white prints, their sheer brilliance, in other words, lends the photographed objects a certain plasticity, a kind of hyperreal presence. What makes these photographs endlessly fascinating is our awareness that there is more to discover in them than immediately meets the eye.

Unlike filmmakers or stage directors, photographers like Dag Alveng always work entirely alone, using the simplest possible equipment to come to terms artistically with the world and its reality. Their ability to engage the objects they photograph in a fruitful dialogue is central to their photography; it is the way they marry form and content. While their photographs are individual works in their own right, they are also meant to be viewed together, as series, for only then are they able to describe the complexity of reality or develop a theme in its many perspectives. The chief aim is not to afford the viewer a «That's just what it's like!» experience through this or that photograph but, rather, to provide as differentiated a view of the world as possible through the works as a whole.

Such photographs are often misconstrued to be documents. This is perfectly understandable, for the photographers do in fact use a documentary photographic style, that is to say, the pictorial language of their photographs resembles that of documentary photography and can indeed be read in the same way. First and foremost, however, these photographs must be understood as the product of the  photographer's artistic self-expression in his endeavor to come to terms with reality. With this kind of photography, too, comprehensibility and credibility are the decisive criteria of appreciation, and yet when looking at them we are altogether aware of their subjectivity, no matter how straight forward they may seem to be. In other words, the photographer gives free rein to his own vision and, in so doing, departs from an objective rendering of the truth. The photographs evidence the difference between the photographer's perception and our perception of a world with which we are both familiar, and it is precisely this difference which makes the photographs interesting. In Alveng's case, too, it is the fact-based fiction of his photographs which distinguishes his work.

The scenery of Dag Alveng's photographs is not exotic. He works in his immediate environment – on the south coast of Norway and, like a diarist who writes with a view to having his diaries published, he narrates personal things, nothing private. Thus, his photographs are not in any way voyeuristic, but they tell a story which rings true. Like the best photographers, Alveng is able to extract from everyday life images capable of taking on a deeper meaning the longer we look at them. Consequently, Alveng's work may be seen as an attempt to broaden our perception of the

world through the medium of photography. Topographical descriptions, portrayals of human beings in specific situations, and the arrangement of these photographs in sequences – all united formally because of Alveng's own way of seeing things – form the backdrop for an ongoing observation of the world. Alveng does not just seek to get to the bottom of things photographically, but also endeavors, with analytical acuity, to reach beyond the limit of what we know or might suspect. The photographer looks at the place on our behalf, examining it as carefully as possible, attempting to comprehend it and its character as well as he can, and then, ultimately, captures in his photographs something which has never been known before, something which begins to dawn on us only as the images unfold. In this way, concrete objects become the means of an experience of self, a completely open-ended experience in which the photographer allows us to participate as equal partners.

By addressing the specific characteristics of the lakeside cottage by name, our son Lennart reassures himself about their continued existence. He does not as yet know what it is to lose a place which is – for him – so important, to retain only the after-image of its memory. In his photographs, which unify the time levels of the past, the present, and the future, Dag Alveng knows exactly what he is talking about: the importance of our family, of our friends, of the people who are close to us; the importance of a place whose value constantly has to be reappraised because it can never be taken for granted; the importance of the light of the summer sun in a country which is essentially cold and dark. Here, everything comes together for just a short time every year. Topography, autobiography, metaphor – these are the photographer's stylistic strategy. Dag Alveng's photographs deal with existential themes – and in order to comprehend them fully we need only to learn to perceive photography as an instrument of perception.

THOMAS WESKI

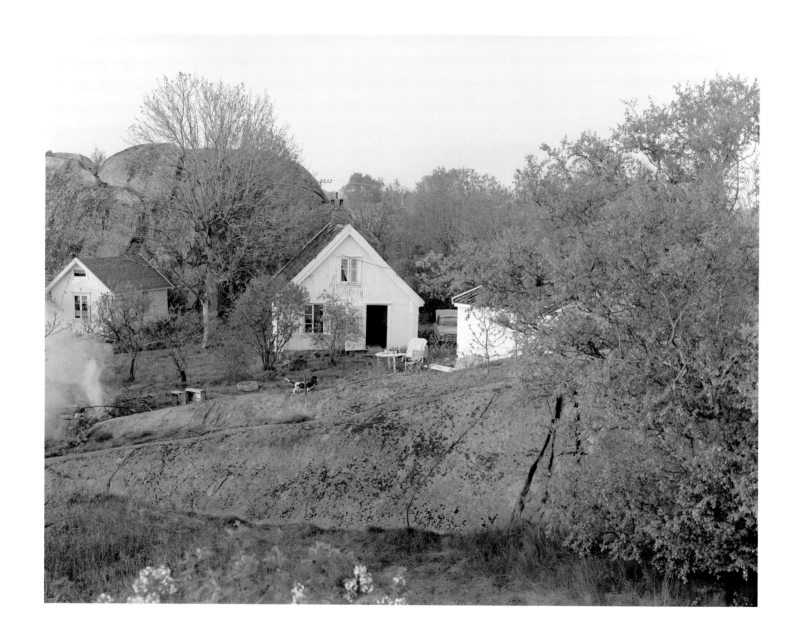

Walking around the House

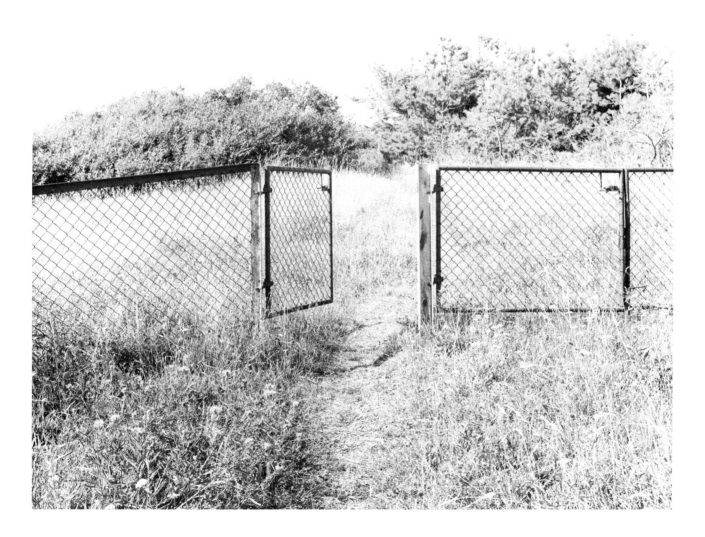

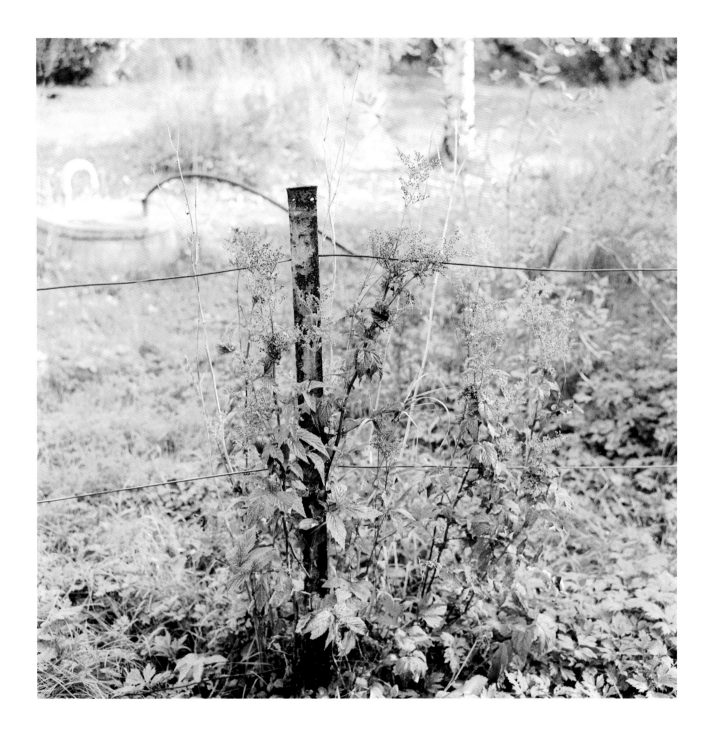

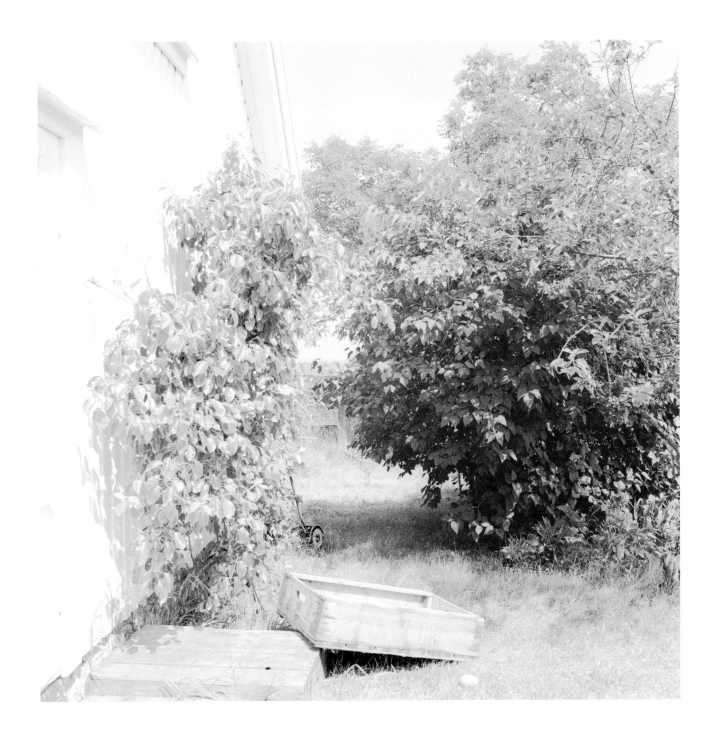

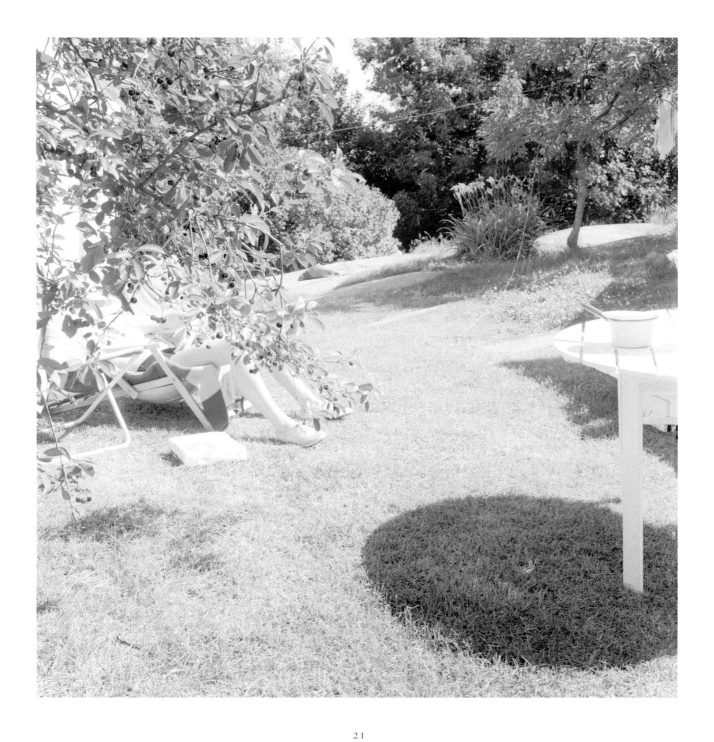

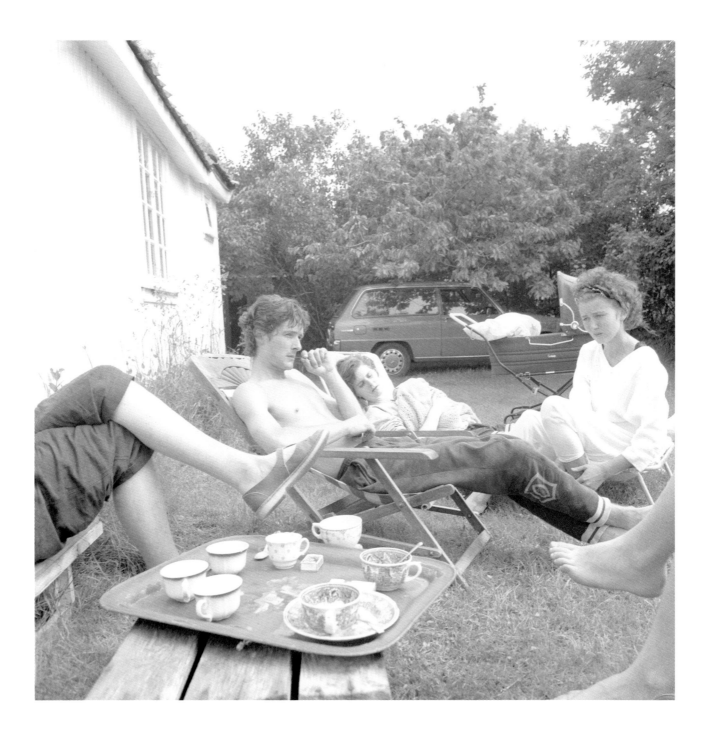

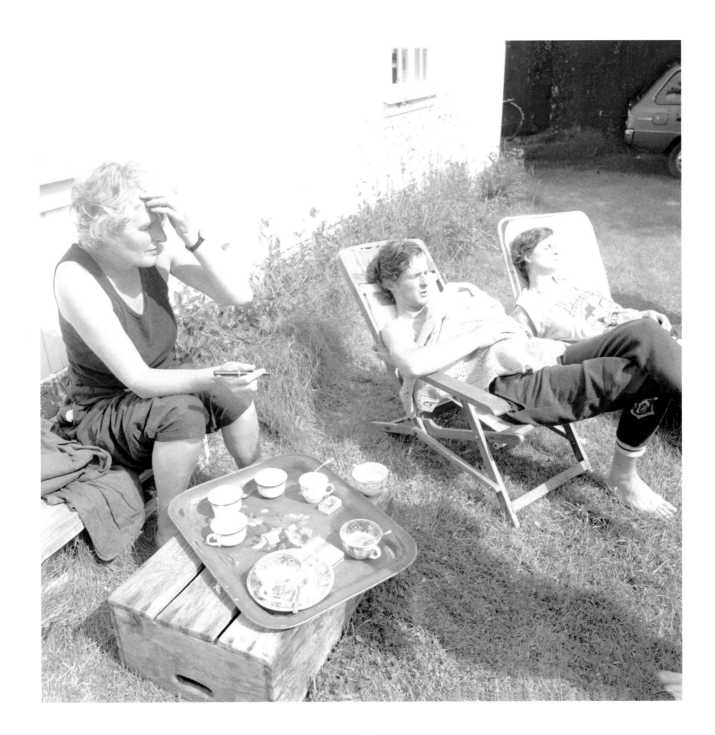

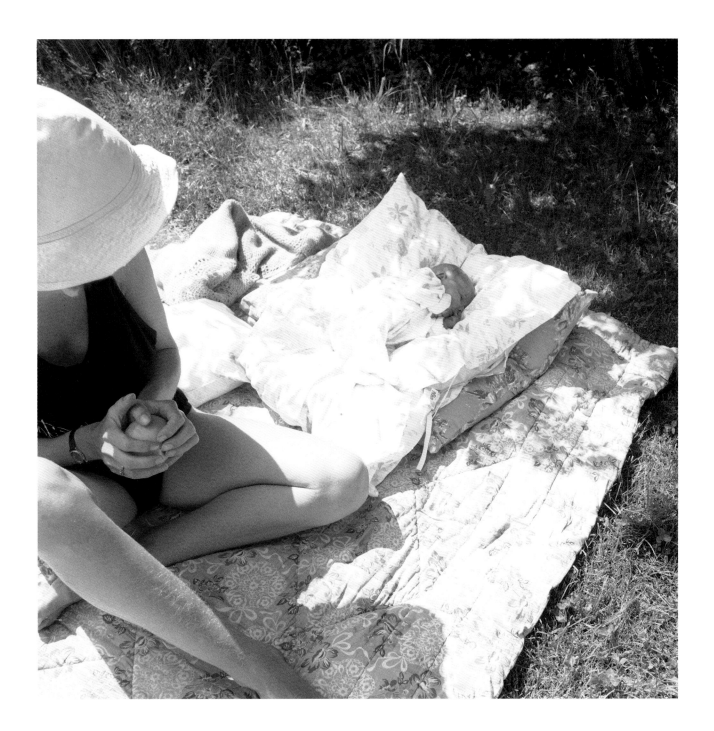

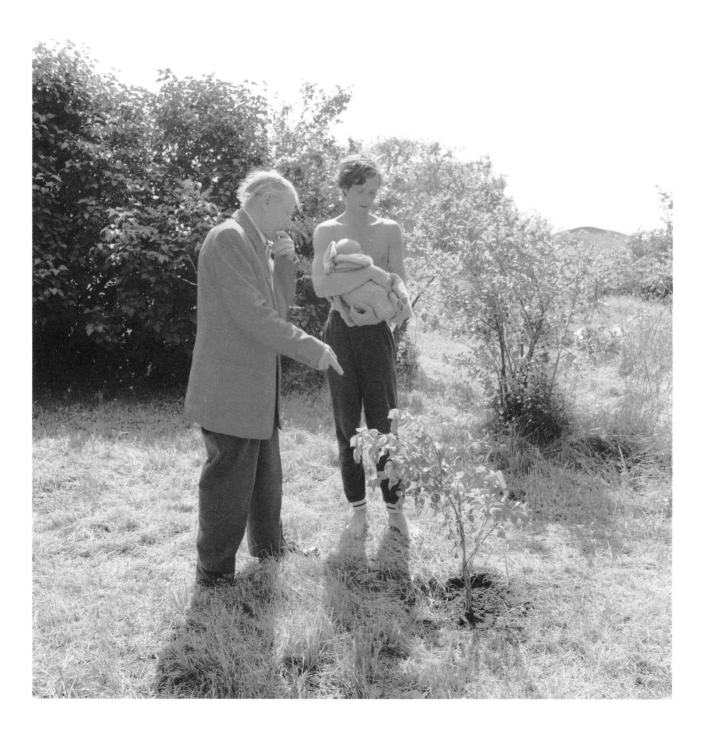

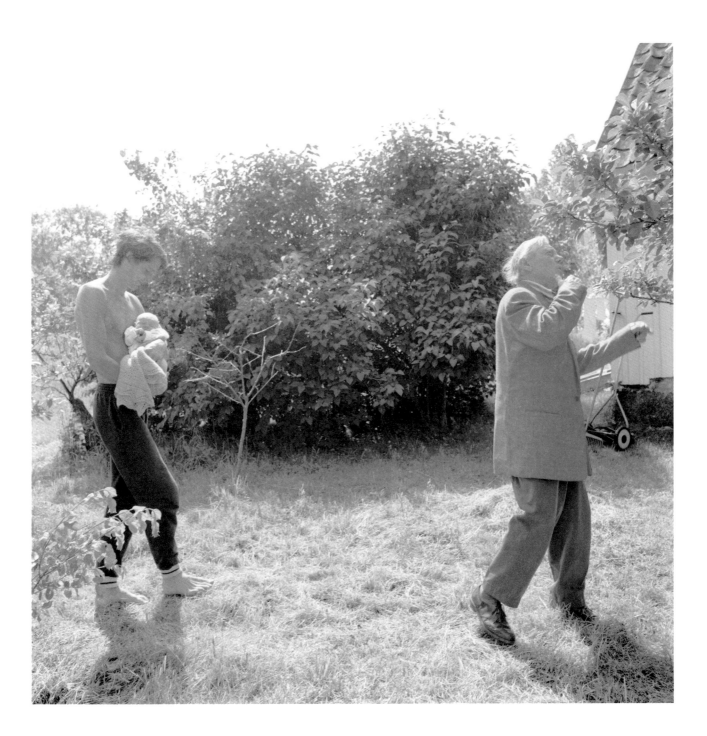

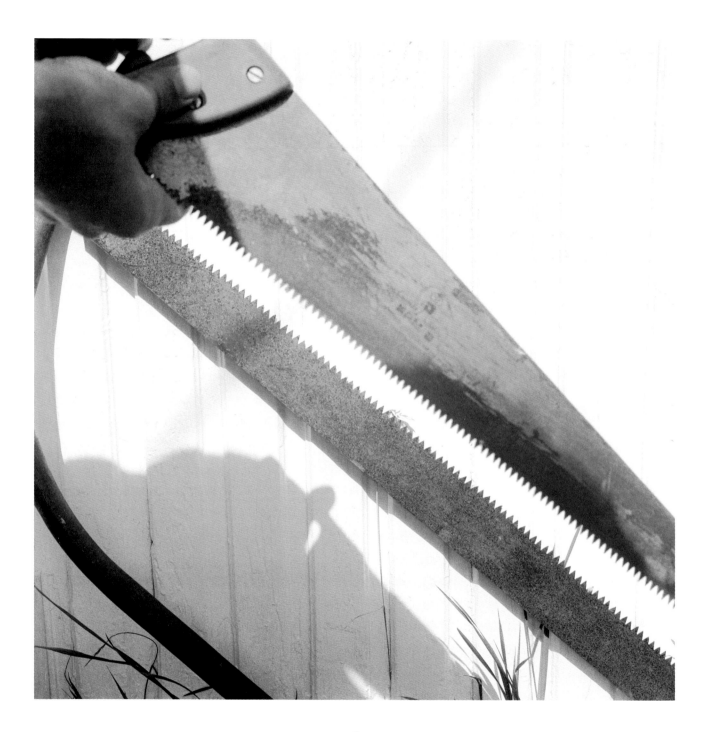

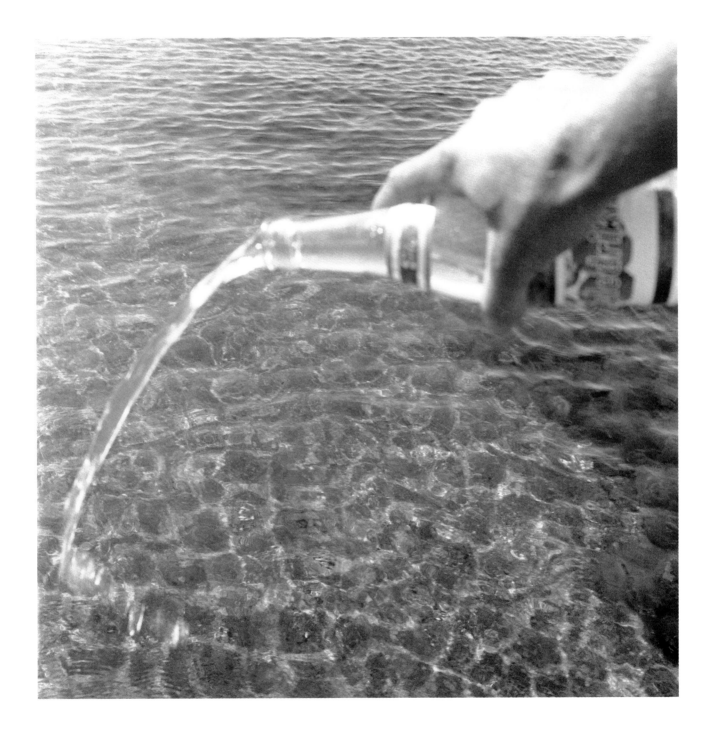

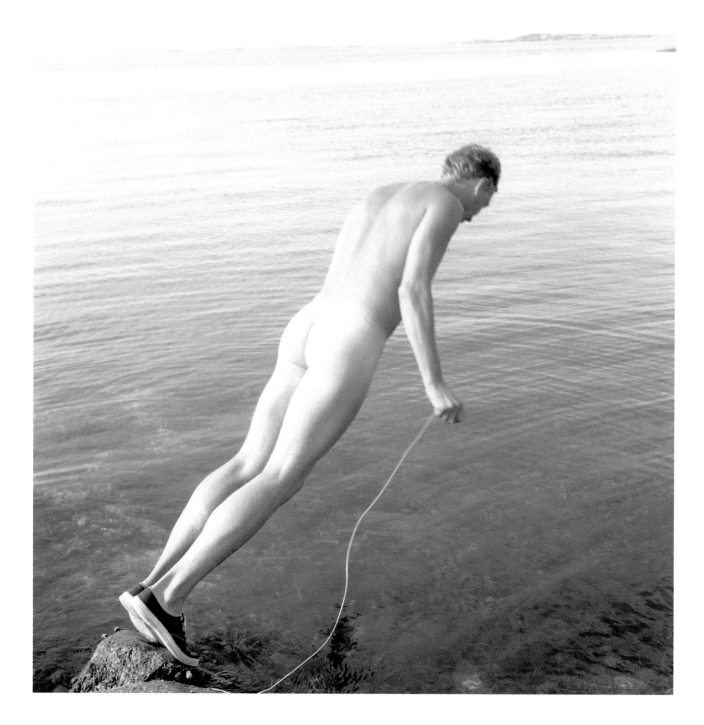

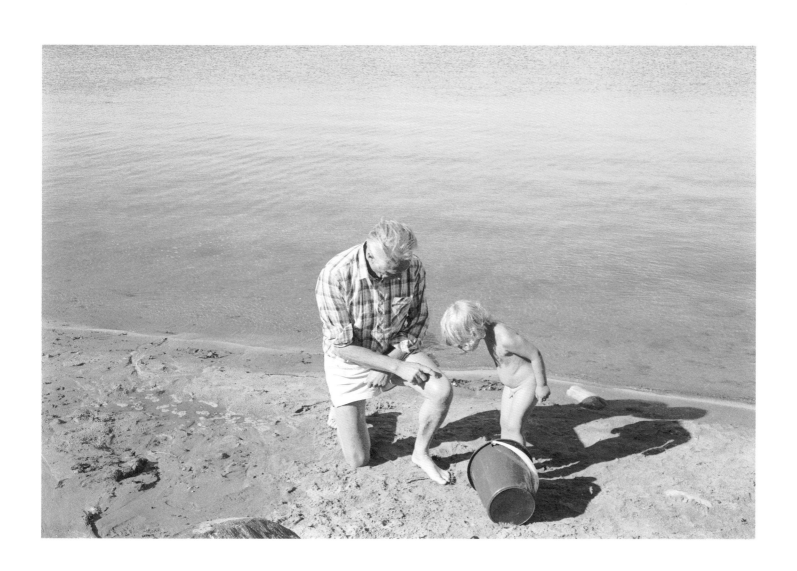

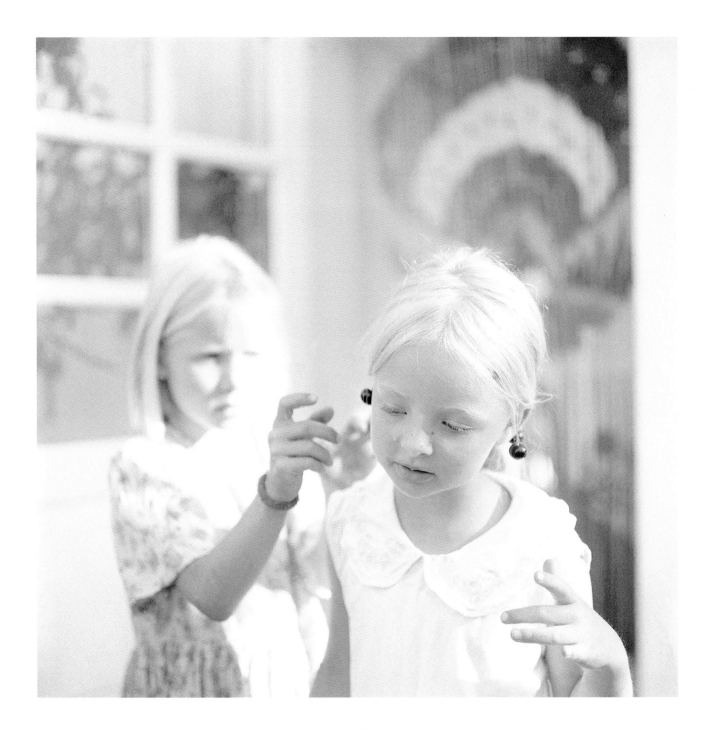

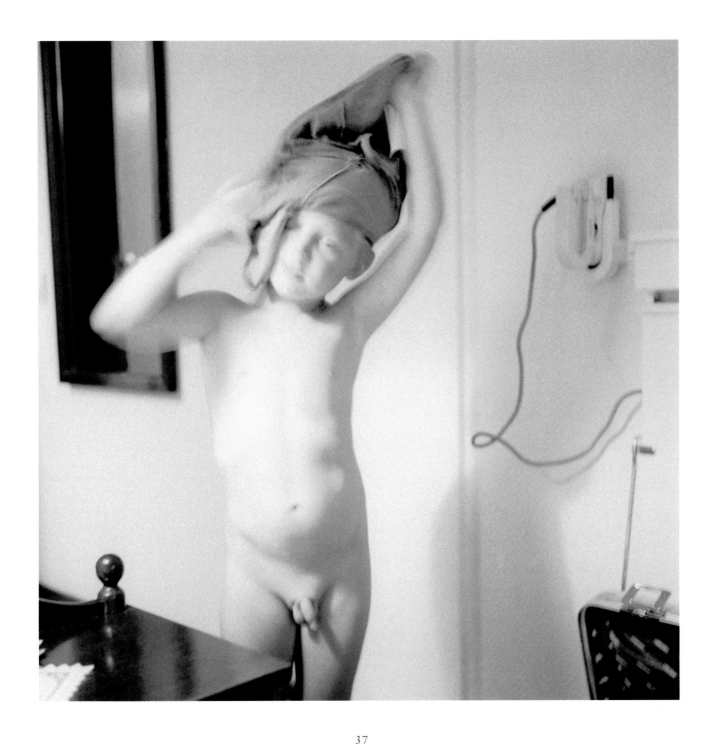

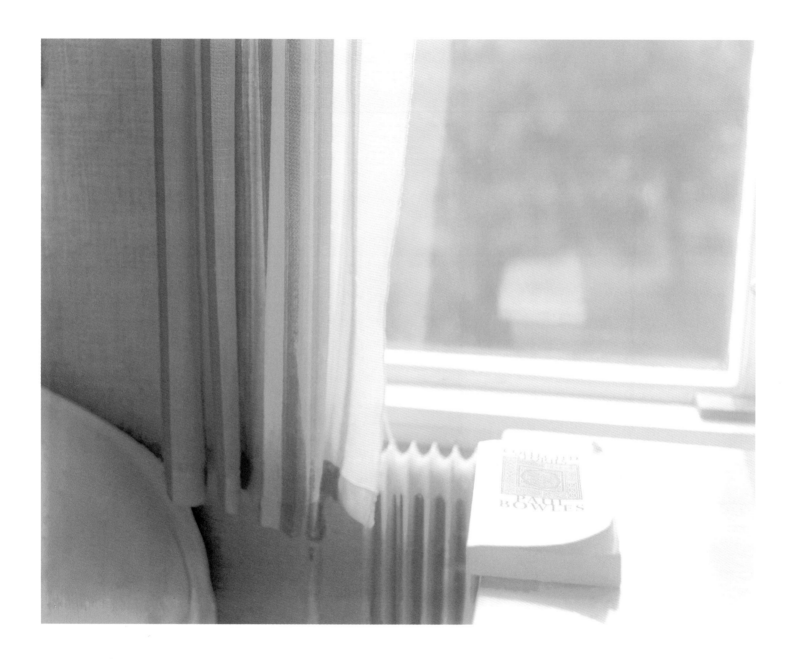

Artists don't take vacations. Their work is their pleasure. Dag Alveng's report of his summer days on an island is therefore not the record of an escape but an embrace.

«Wherever there is light one can photograph,» Alfred Stieglitz encouraged, and a corollary is that summer, with its long days, is the best of seasons. Particularly in the North. Photography there reminds me of my wife's recollection of what it meant to be a child in summer near Koster. «We never wanted to go inside.»

In summer, light wins. The birds sing every hour. We stand unafraid in the long twilight, as if in a Sienese painting, the air gold. Summer light makes permanent a summer place.

We bring to such places what we cherish: favorite and promising books, comfortable clothes, the implements of picture-making, friends and family. We trust these loved things to weak defenses, to buildings that may not stay warm, to a rocky landscape where accidents could happen. By the promise of the light, we dive into the water. By the same assurance we go to sleep in the lawn chair.

Dag Alveng's photographs are as peaceful as their subject. W. H. Auden wrote, in the poem «IN MEMORY OF W. B. YEATS», that «poetry makes nothing happen.» That is part of the blessing that these pictures give us. Along with gladness. The photographer does what Auden asked the poet to do:

> *With your unconstraining voice*
> *Still persuade us to rejoice.*

ROBERT ADAMS

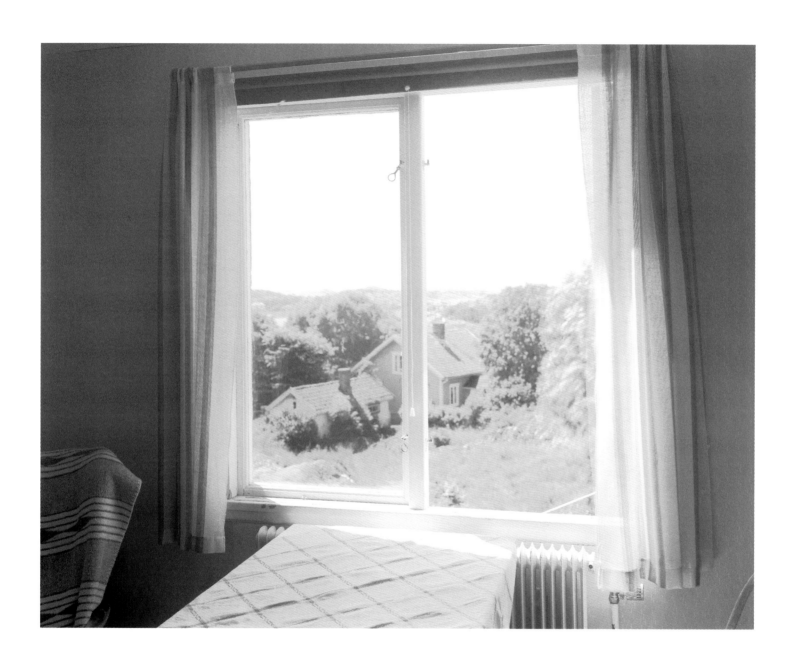

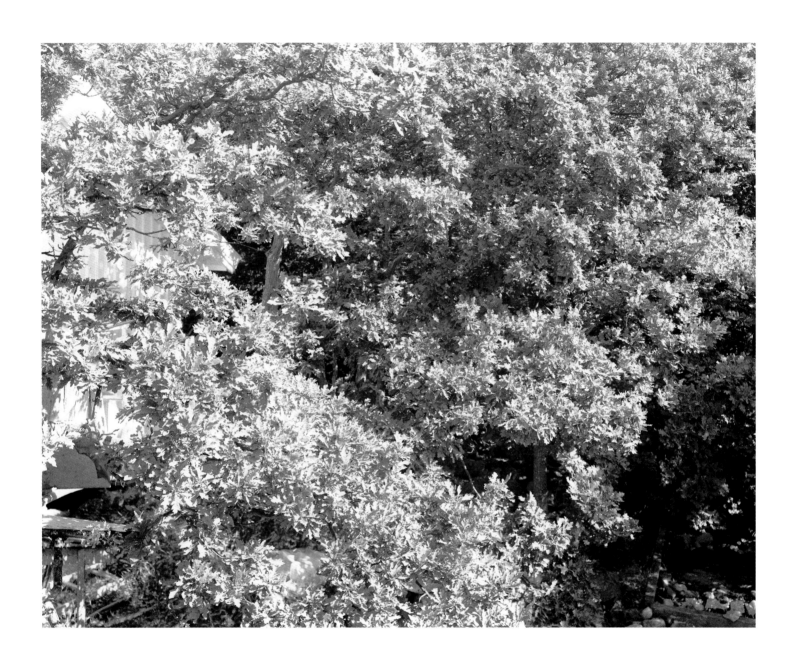

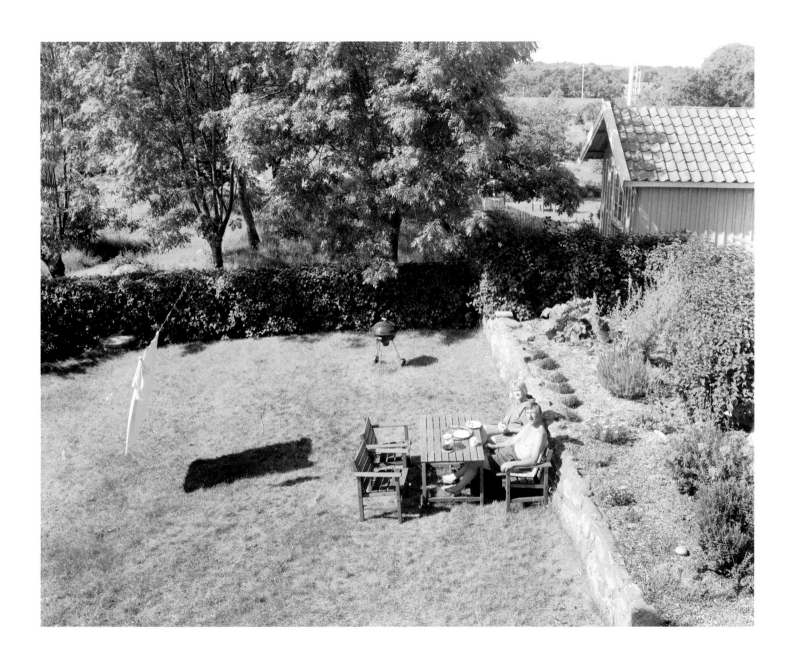

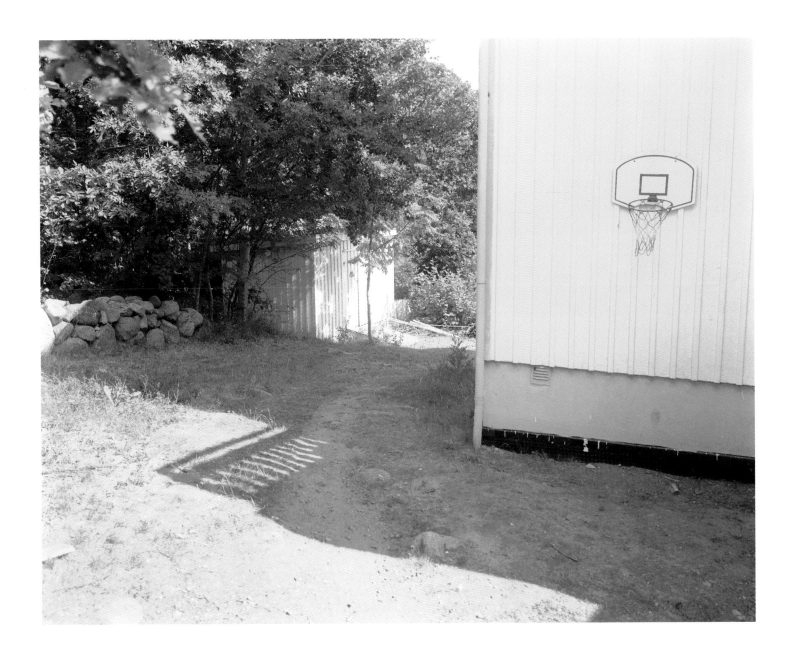

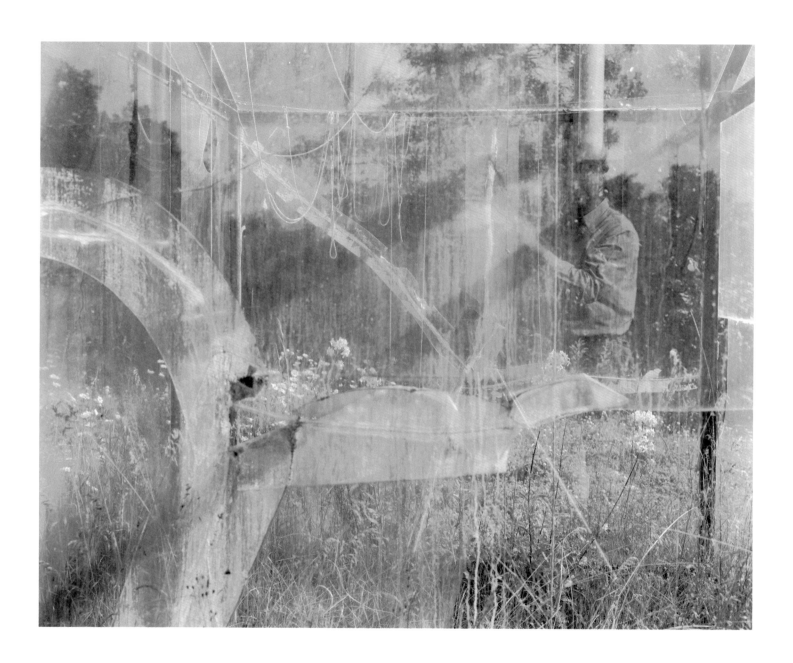

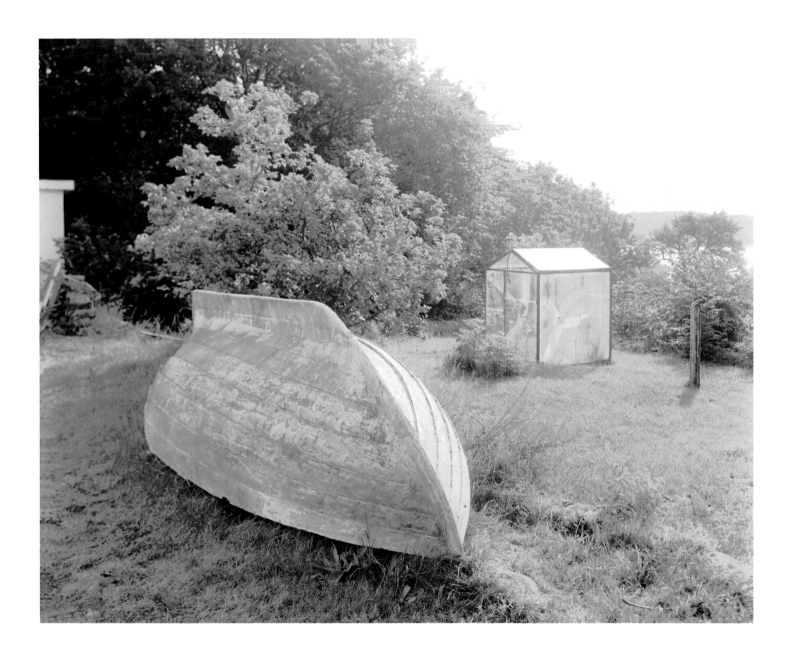

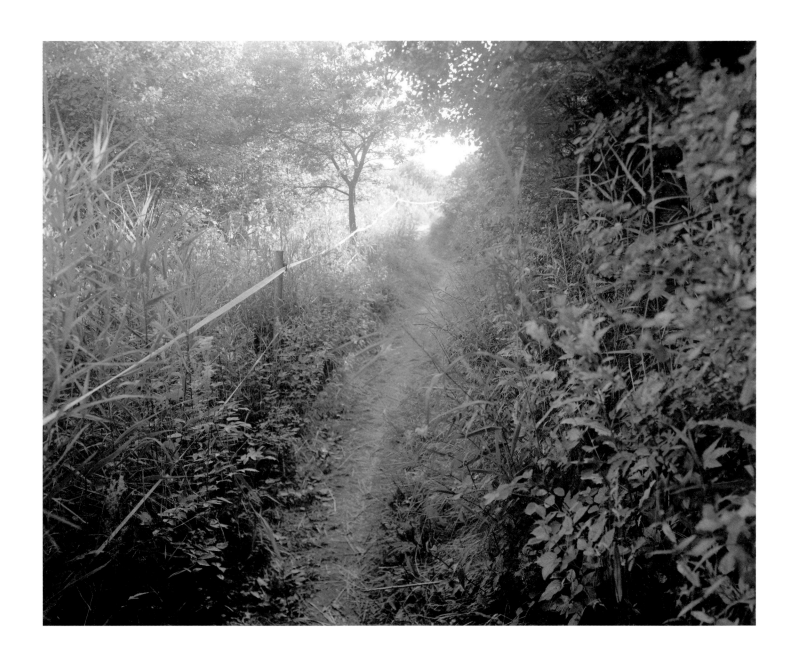

The Path to the Ocean

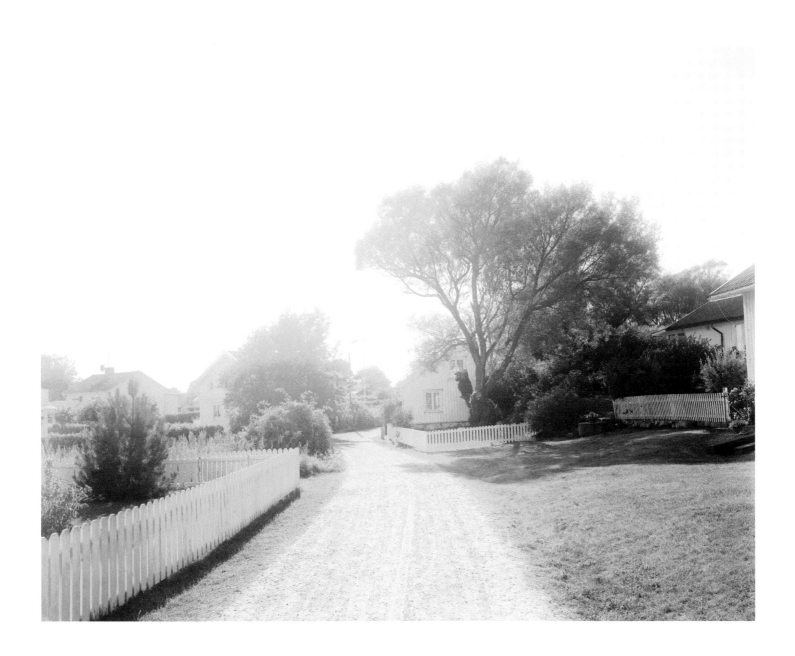

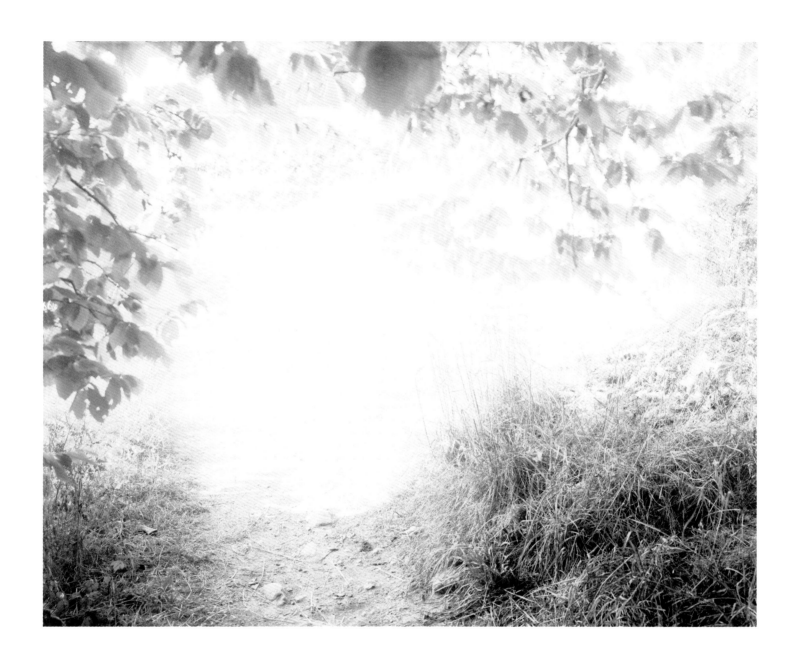

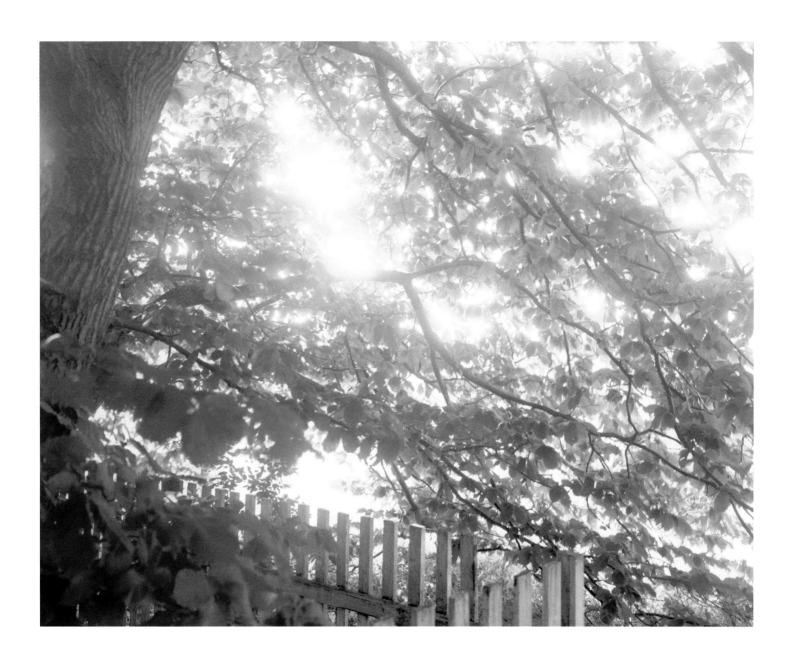

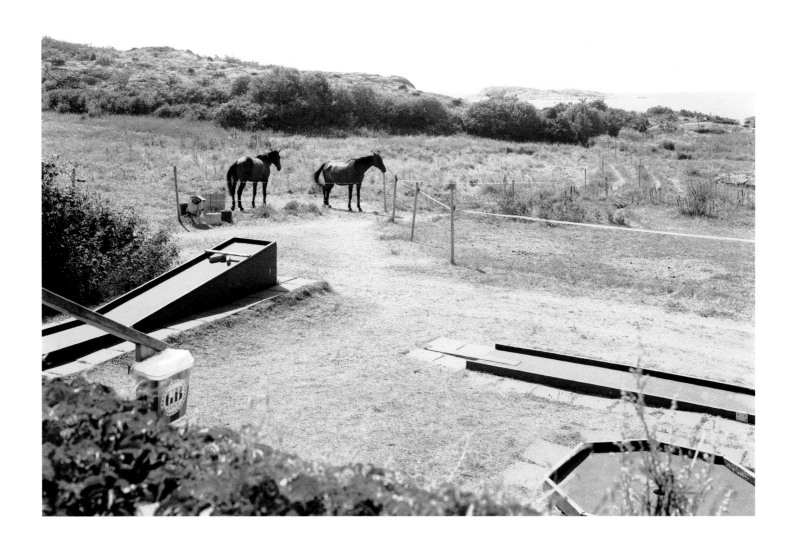

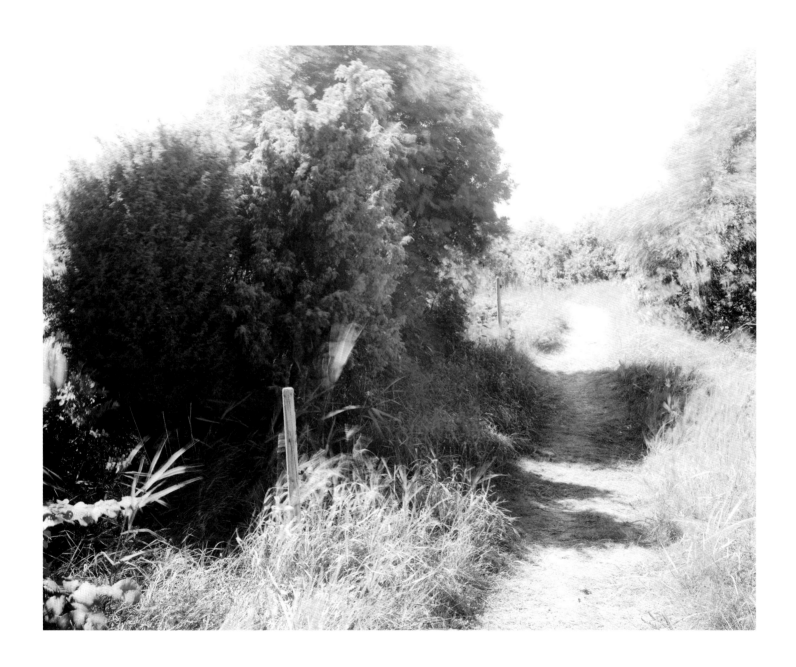

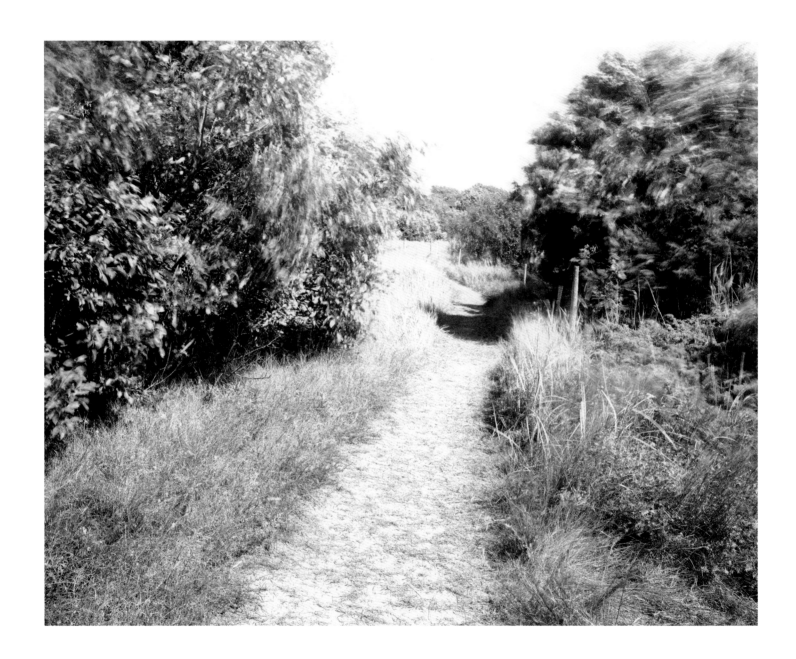

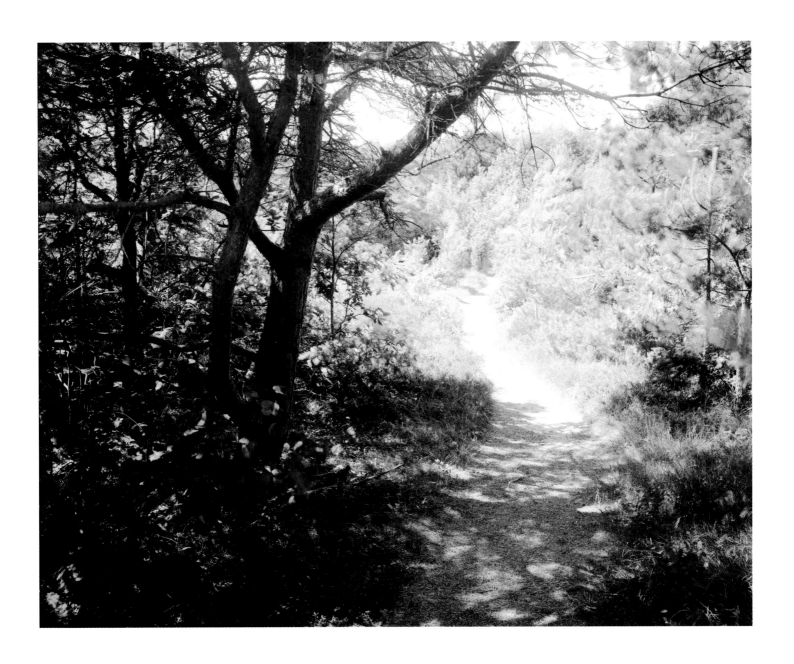

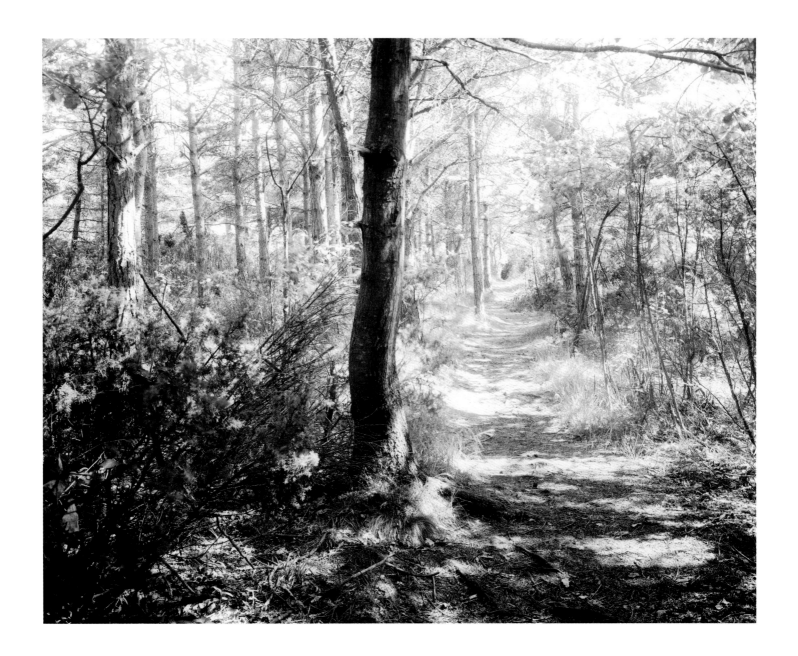

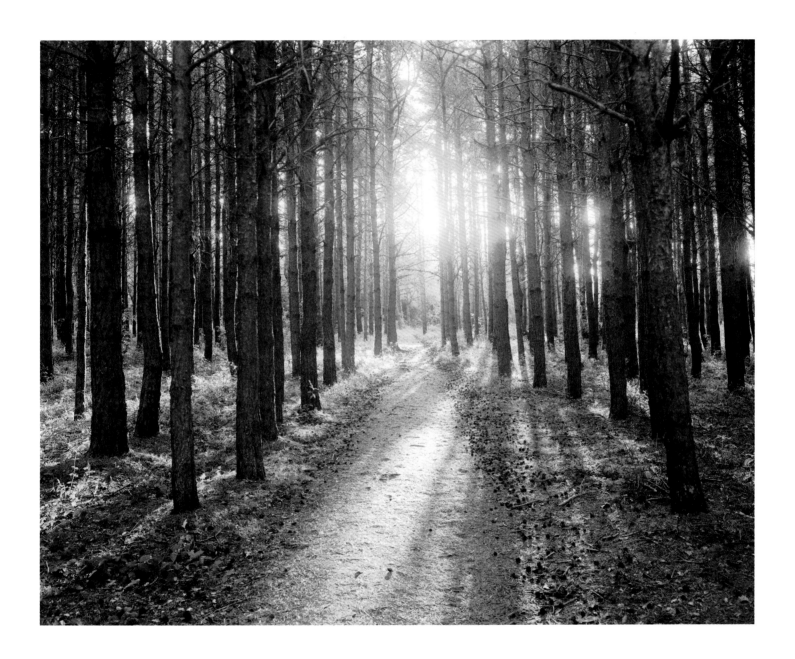

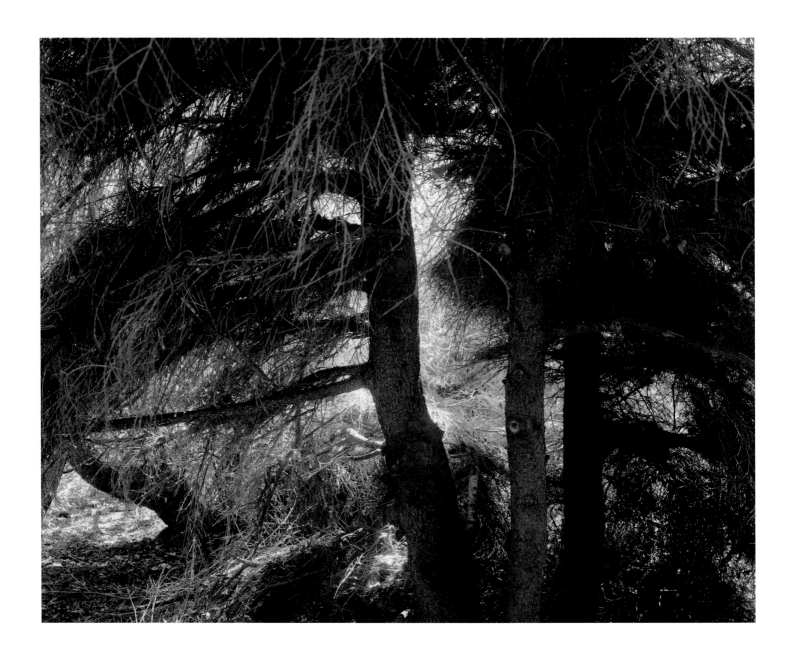

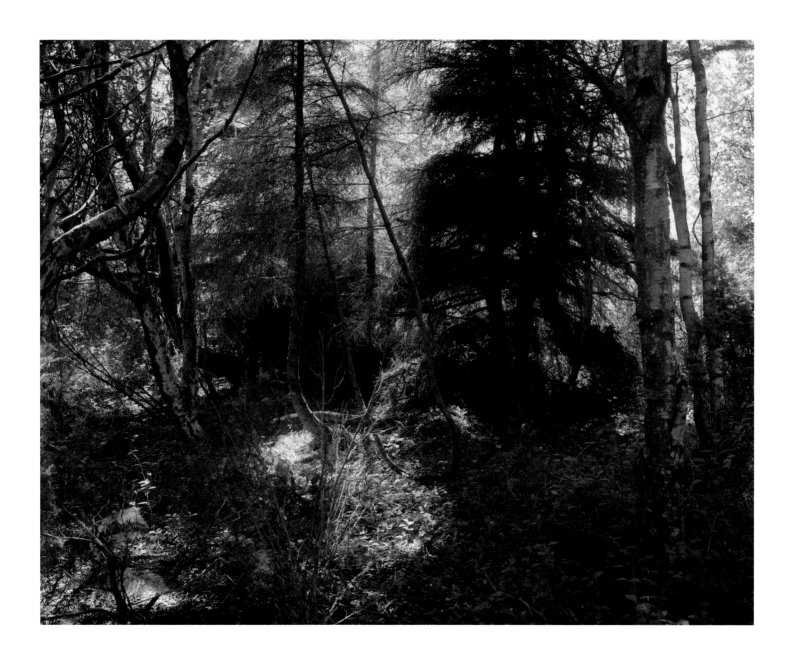

69

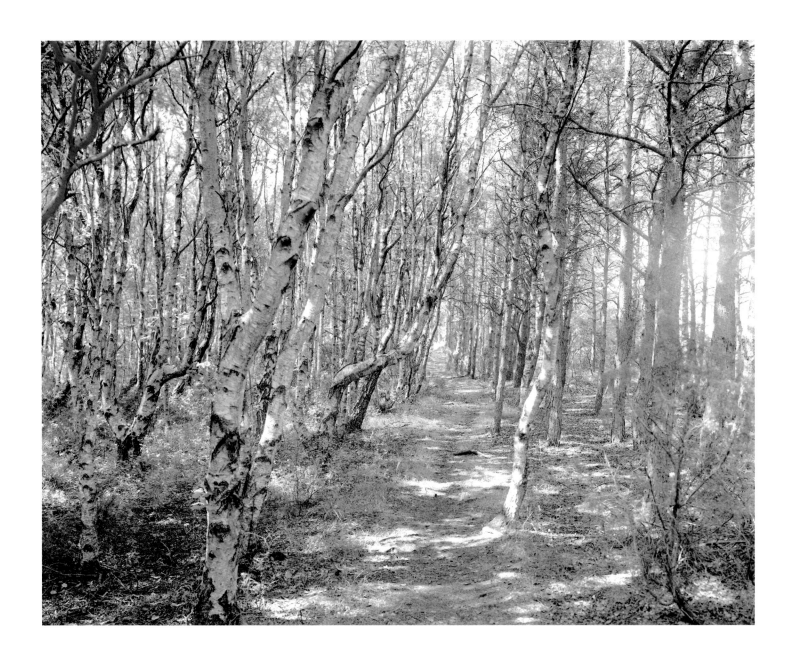

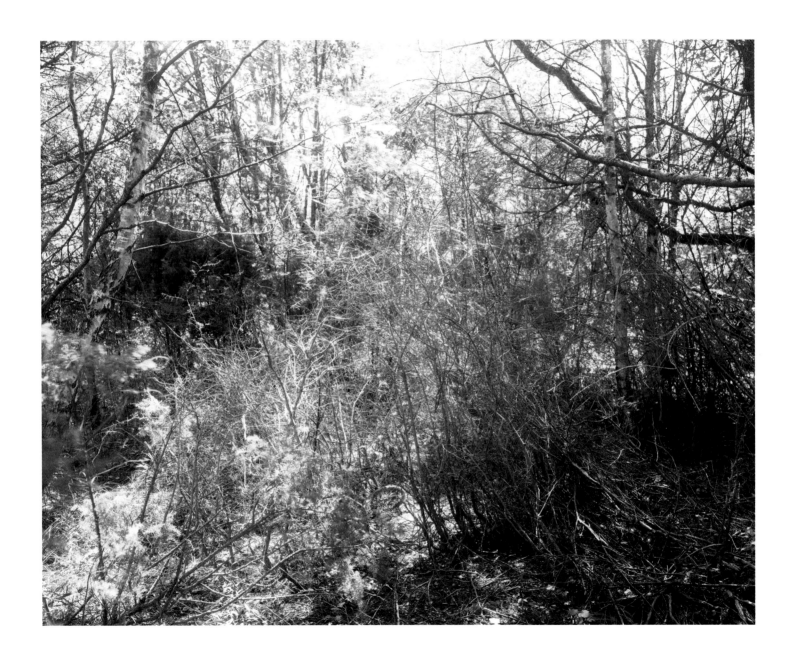

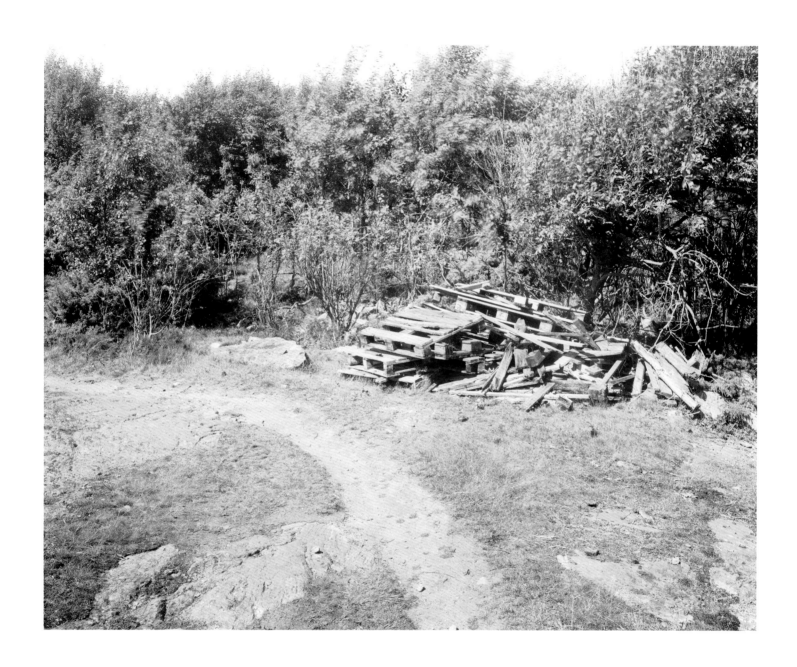

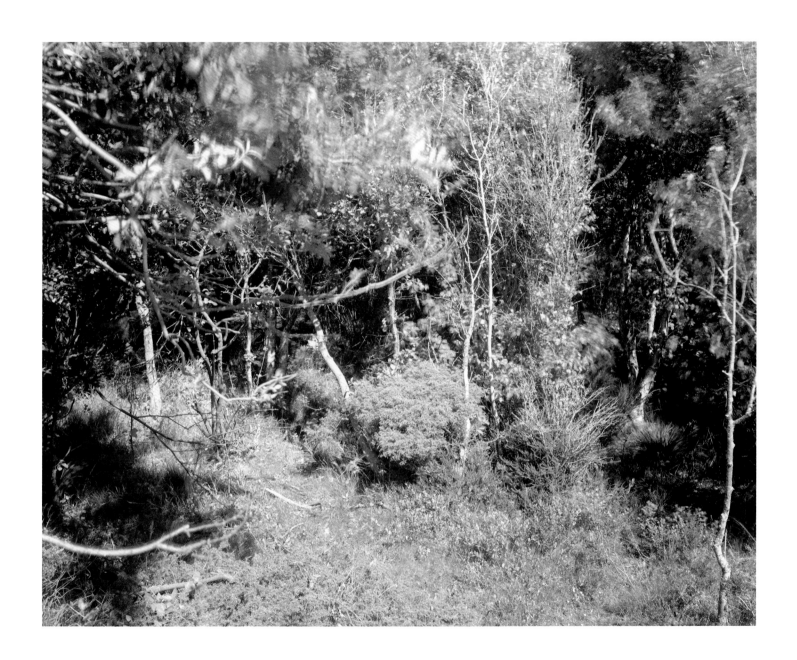

75

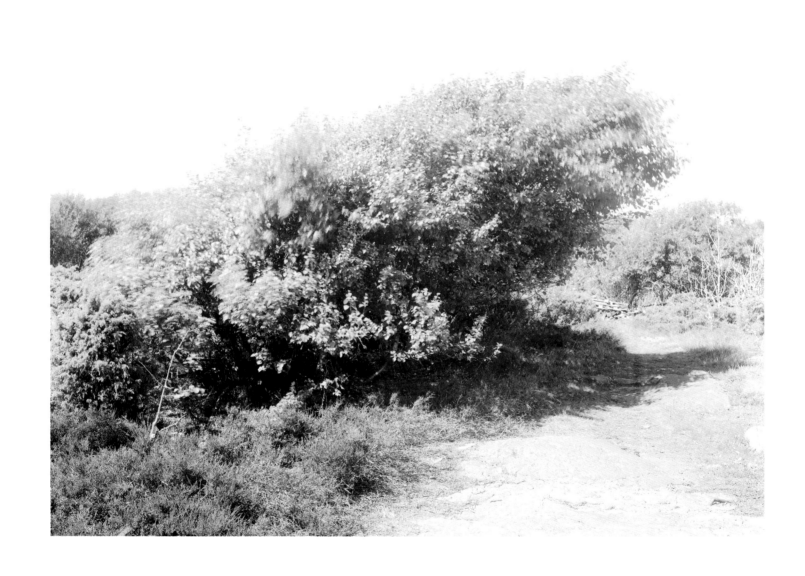

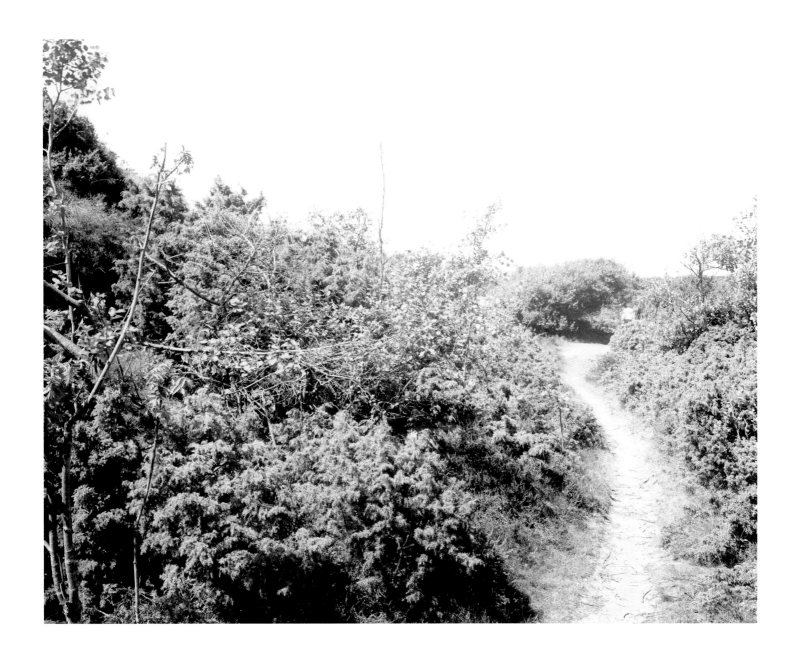

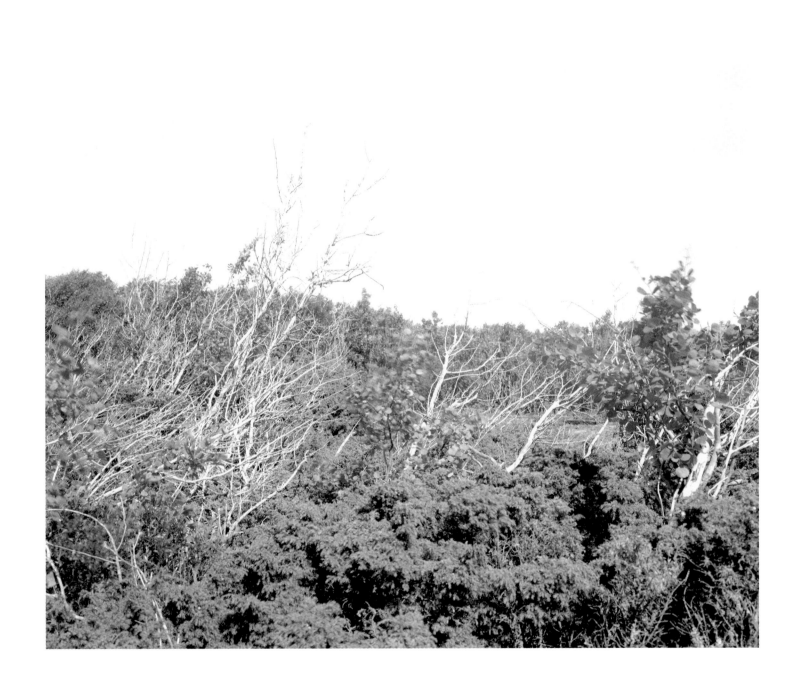

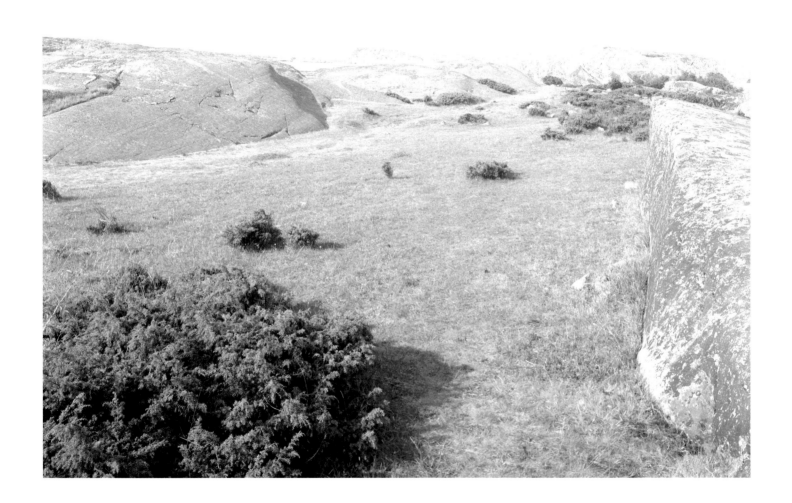

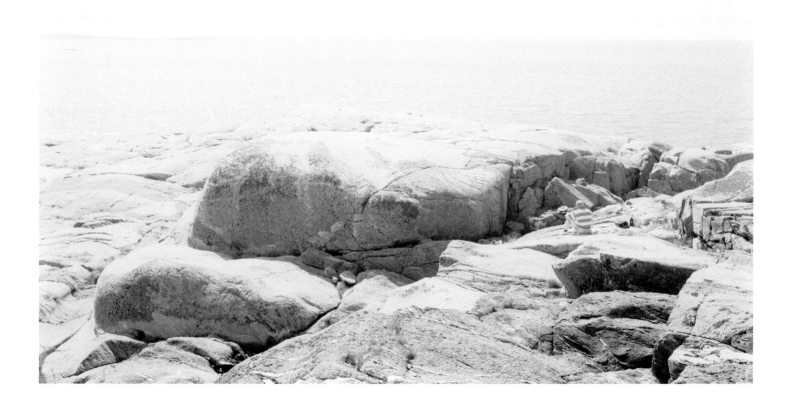

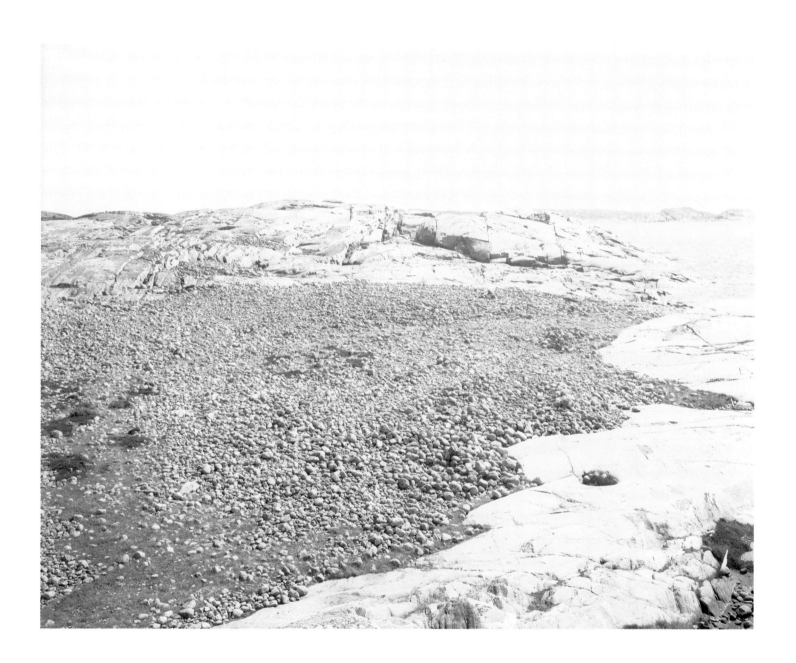

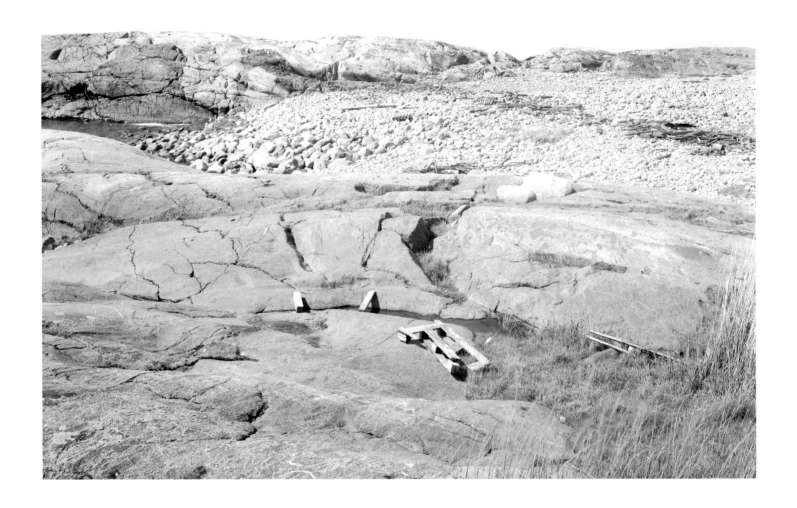

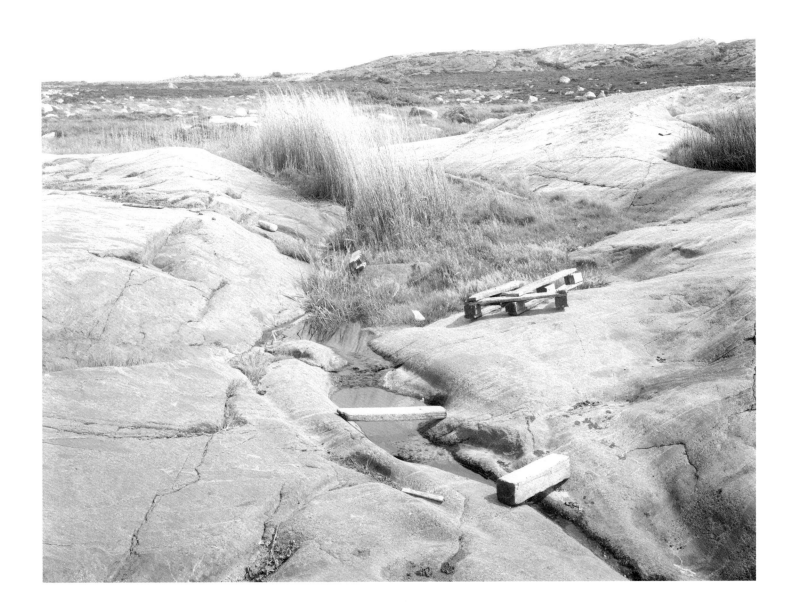

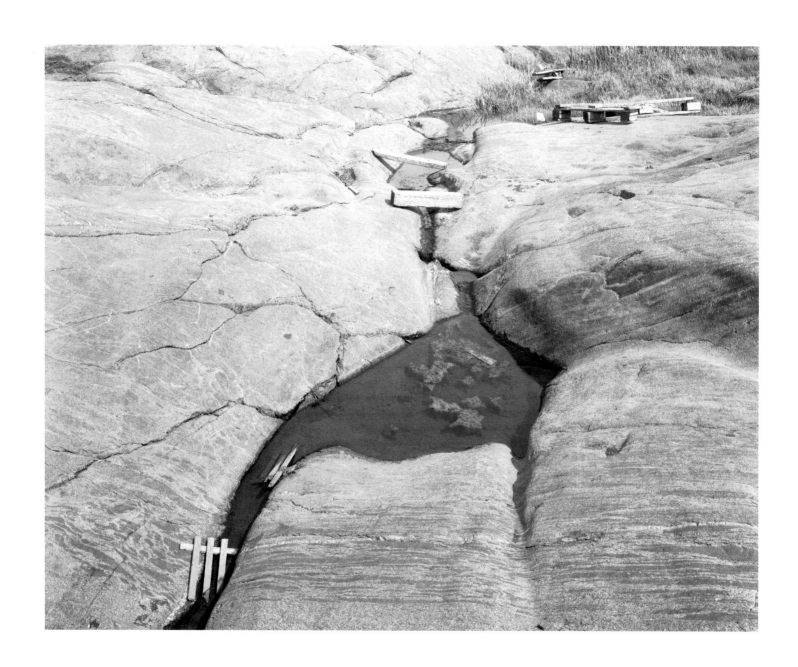

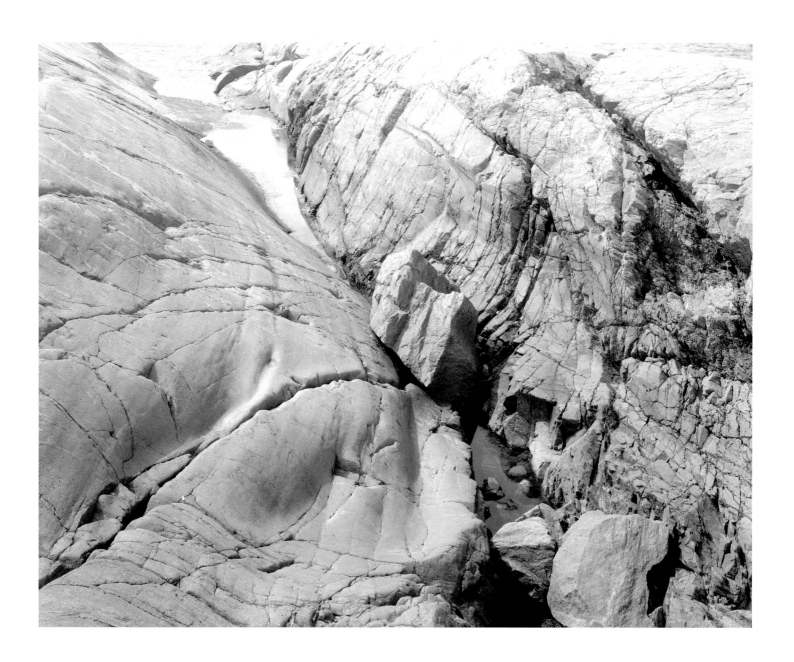

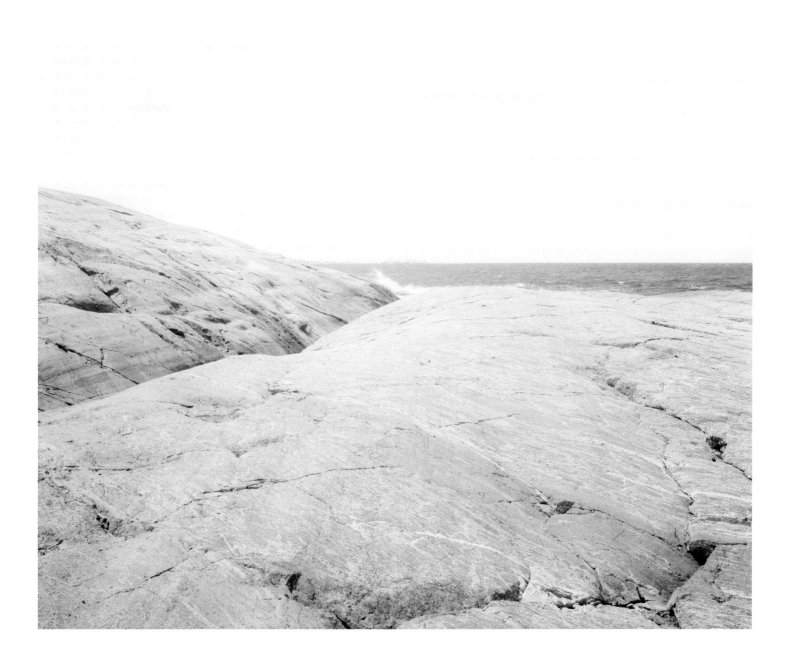

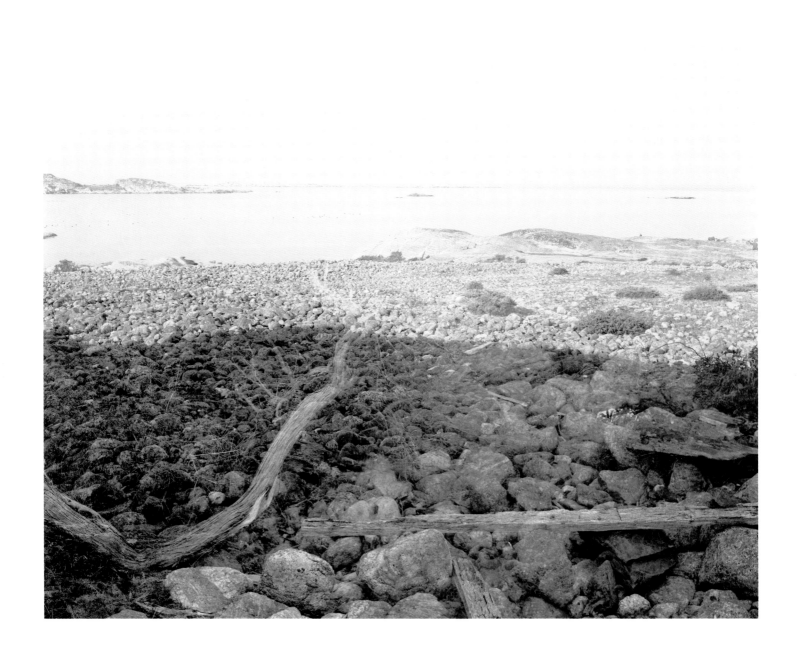

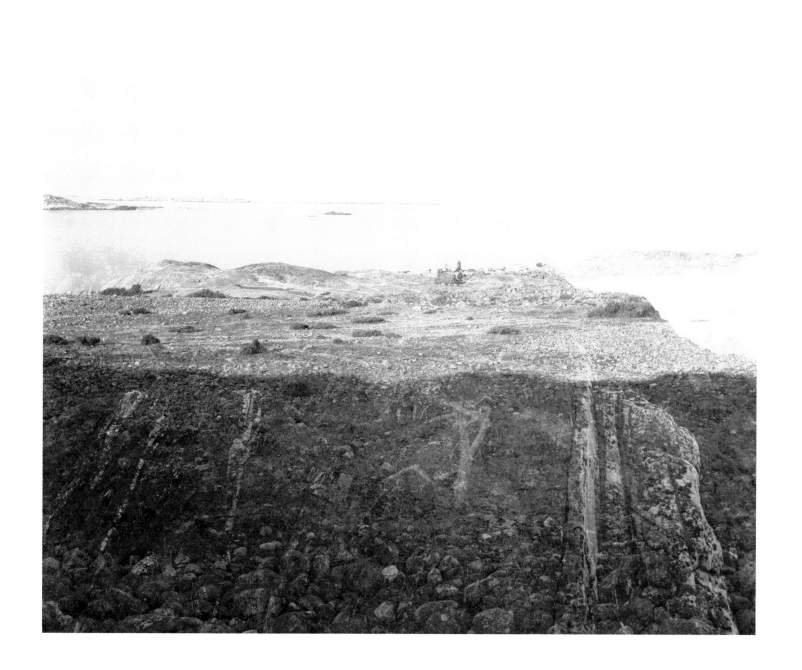

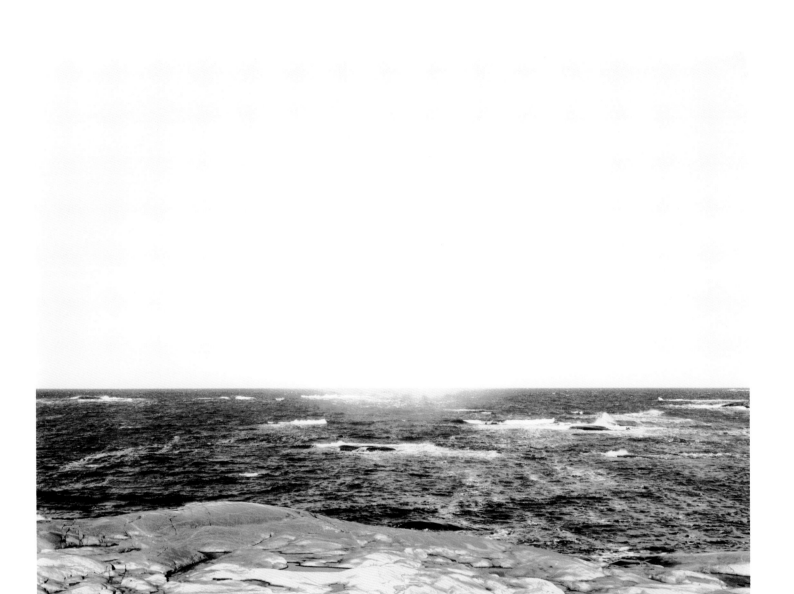

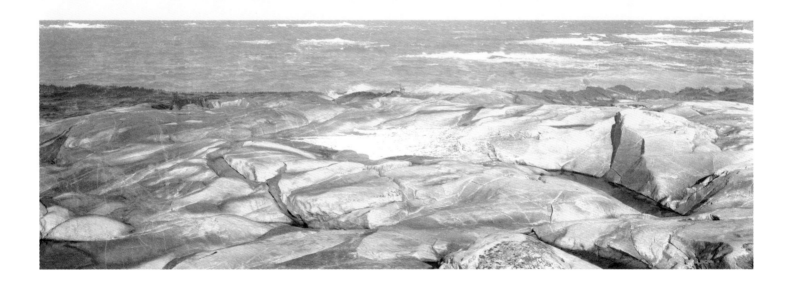

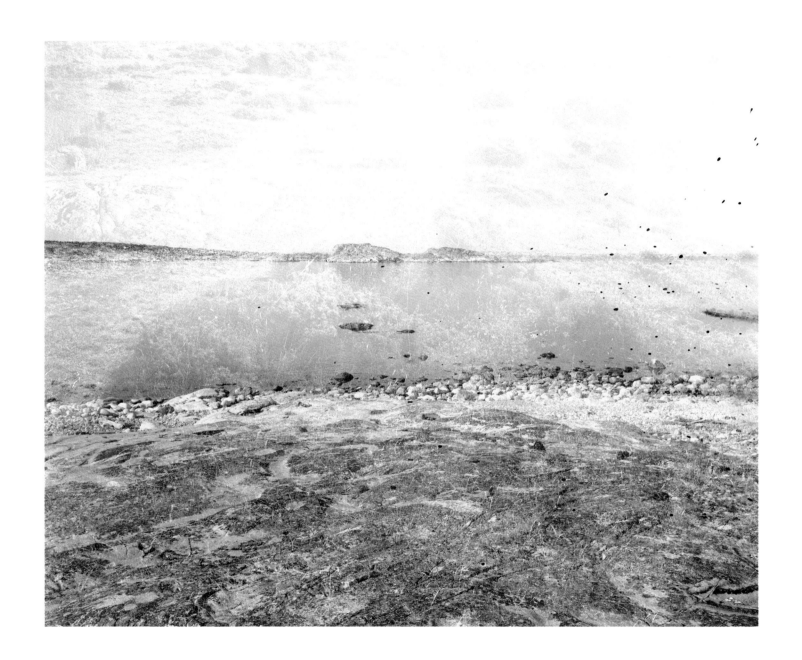

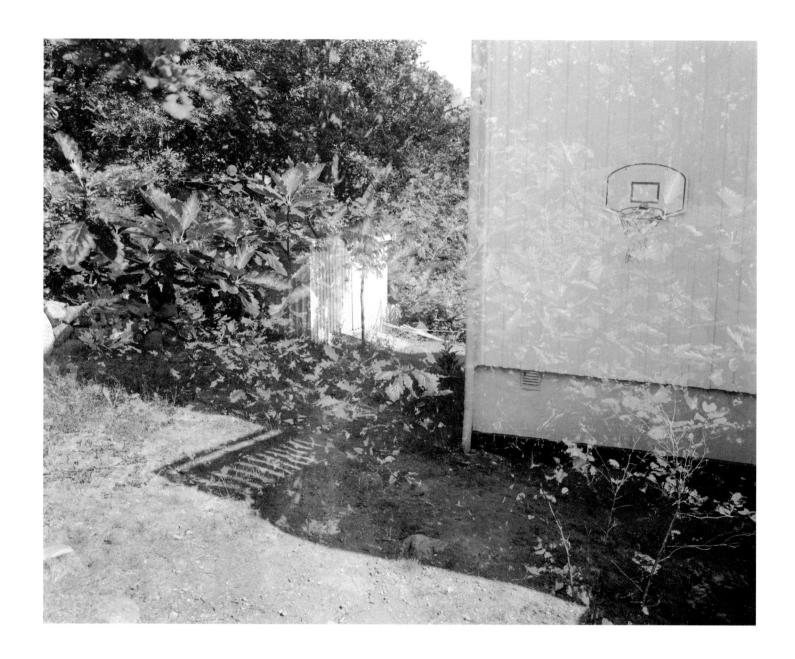

# Summer Light

WHY DOES DAG ALVENG'S SUMMER LIGHT series keep cropping up in my mind? What is it about these photographs that fascinates me, especially when they don't appear to be about one thing in particular and don't have any obvious dramatic form? To put it simply, it's the light – the Nordic light, and of course, the silence, and, certainly, the places themselves.

Alveng weaves the commonplace and the beautiful together in this moving series made over the past twenty years in the coastal villages of Hvasser and Koster, places he has visited regularly since he was a child. One of the photographs, *Open Gate, Hvasser*, 1979, is already an icon in the history of Norwegian photography. There is nothing spectacular about its subject. The photograph shows an open, weather-beaten gate in a flat landscape. We don't know if the gate represents freedom or containment, whether passing through the gate is an interruption or a continuation of an event. The photograph is about light, and Alveng uses grey tones from the upper end of the tonal scale to create his composition, in some parts of the image bravely eradicating the subject itself.

Alveng's work has always been distinguished by its technical quality. Influenced by American photographers Robert Adams, Lewis Baltz, Harry Callahan, and Ray Metzker, Alveng emphasises what might be called particularly photographic qualities in his images: sharp depth of field, rich depiction of details, and a wide tonal range. However, in his SUMMER LIGHT series, Alveng accentuates the tones at the top end of the grey scale to interpret the unique summer light in the Nordic countries, the real subject of his series.

In the group THE PATH TO THE OCEAN, made in the late 1990s, Alveng ventures away from the immediate surroundings of his summerhouse, towards the sea at Koster, moving through the woods that surround his house. In the woodlands, Alveng becomes playful as

he depicts the contrast between light and shadows. In several photographs, the dark areas of the forest are prominently in the foreground, and Alveng emphasises the surface of bark and the rhythmic play of branches. Sunlight is the backdrop of these pictures, and in certain images it falls like a spotlight on the thick, dark forest. In *Tree Trunk and Path*, 1996, we leave the shadowy forest behind us. Sunlight oozes through the trees, creating a dazzling opening that reveals the sky. The picture is an interlude on the way to the sea. In other images from this series, Alveng records traces of human existence in the debris he finds along the way, particularly in the rocks along the sea. Standing at the ocean's edge, Alveng pictures the overpowering light, that intense, almost white energy of light on a summer's day.

The photographs in THE PATH TO THE OCEAN, are distinguished by a singular silence. The calm atmosphere in the pictures is reiterated by their even tones, a smooth transition from white to black tones. Where people occur they are small figures in an immense landscape. In *Couple on Bare Rocks*, 1996, we don't spot the people at first glance; they more or less blend into the rocks, bathed by an almost white sunlight. Instead of emphasising the more predictable harsh contrasts that sharp sunlight can create, Alveng recreates a kind of visual memory – one in which light functions as if it were passing through a finely meshed filter. It is as if the light were not just illuminating the landscape but was in the landscape itself.

In his double exposure series, by fusing two images that seem to float into each other, Alveng recreates dreamlike light, the kind of hazy light we experience on certain kinds of summer days. It's as if such hazy light hinders us from focusing on a single point in the landscape. In the photograph of the window of the summerhouse, *Window and Branches* [Double Exposure], 1997, a network of leaves is clearly visible in the dark areas of the interior. Another double exposure – of bare rocks and sea, *Horizon and Sun* [Double Exposure], 2000 – is a real, but diffused, double vision, in which our sense of time is confused. Shadows cast by the sun break up in two directions so that the sun seems to be in two different places, at two different times of day, an experience we do not normally have when we look at photographs.

When Alveng studied at Trent Polytechnic in Nottingham in the late 1970s, he was impressed by the American photographers identified with a recently defined movement in American photography called the «NEW TOPOGRAPHICS.» «NEW TOPOGRAPHICS» was the name given to a group of loosely related photographers – Lewis Baltz, Robert Adams, Bernd and Hilla Becher, among others, whose work referred to the nineteenth-century documentary tradition of American landscape photography. The photographers who defined this movement aimed at creating a neutrality in their images – an «objective» point of view some critics observed – by playing down the dramatic effect that light could have in revealing a subject, any extreme angles, or, for that matter, any details that might emphasise the subject of their photographs. In Alveng's earlier photographs in the SUMMER LIGHT series he uses this even distribution of light. But in his more recent images in the series he uses different qualities of light to reveal his subject. At times, he even abandons his «objective» distance to move in closer, including more detail in the image than previously, rendering the subject in darker tones.

*Electric Fence*, 1997, a picture of a fence alongside a path, is taken from an overgrown trail. There is a poetic fullness to the picture, arising in part from the blurred grass near the edge of the picture and from the light streaming in from an unseen point somewhere among the trees. A fence, very sharply rendered, is the nominal subject of the picture, but it is when the viewer realises that the tape is the fence that the mood of the picture is broken. It is Alveng's quality of seeing the world the way he does and his determination to find the absolutely right metaphors to depict that vision that distinguishes him as an artist who has described the essence of Norwegian summer light like no other artist before him.

EVA KLERCK GANGE

# Titles

This book is being published in connection with the exhibition
SUMMER LIGHT at the Sprengel Museum Hannover, March – May 2001
and the Museum of Contemporary Art, Oslo, June – September 2001

Copyright DAG ALVENG and FORLAGET OKTOBER AS 2001
Editors CAROLE KISMARIC and INGERI ENGELSTAD
Design EGIL HARALDSEN | EGIL HARALDSEN DESIGN STUDIO AS
Translation JOHN BROGDEN and AGNES LANGELAND

Halftone scanning in Quadratone by KRISTIAN GRØNLI
Compressed and sent through the internet WITH TECHNOLOGY FROM FileFlow
Printing Consultant RICHARD BENSON
Production supervised by GRØNLI-GRUPPEN AS ved KNUT GRØNLI, and DAG ALVENG
Printing KRONE TRYKK AS 2001
Paper 170 G GOTHIC SILK delivered by BASBERG PAPIR AS
Typesetting by EGIL HARALDSEN DESIGN STUDIO AS
Fonts used in this book MONOTYPE BEMBO, LINOTYPE DIDOT and MONOTYPE GILL

This book is supported by FILEFLOW AS
THE MUSEUM OF CONTEMPORARY ART, OSLO
SPRENGEL MUSEUM HANNOVER
THE NORWEGIAN COUNCIL OF CULTURAL AFFAIRS
THE NORWEGIAN DEPARTMENT OF FOREIGN AFFAIRS
and INGRID LINDBÄCK LANGAARDS STIFTELSE

Printed and bound IN NORWAY

ISBN 82-495-0040-7

Published by FORLAGET OKTOBER AS, OSLO, NORWAY

Distributed by D.A.P. | DISTRIBUTED ART PUBLISHERS
155 6TH AVENUE, NEW YORK CITY,
NEW YORK 10013, USA
Phone 212-627-1999
Fax 212-627-9484

Distribution in Europe KONST-IG AB
Phone +46 8 508 31 517
Fax +46 8 508 31 519
www.konstig.se

Without the generous support of certain individuals, institutions and companies, this book would not have been possible

Thanks to

Thomas Weski  SPRENGEL MUSEUM HANNOVER, GERMANY
Per Bj Boym and Eva Klerck Gange  THE MUSEUM OF CONTEMPORARY ART, OSLO, NORWAY
Nils-Johan Pedersen and Espen Brodin  FILEFLOW AS
Gerhard Ludvigsen  GL-GRUPPEN AS
Knut and Kristian Grønli  GRØNLI-GRUPPEN AS
Geir Berdahl and Ingeri Engelstad  FORLAGET OKTOBER AS
Egil Haraldsen  EGIL HARALDSEN DESIGN STUDIO AS
Geir and Svein Halbing  KRONE TRYKK AS
Arild Holtlund and Torill Strøm  BASBERG PAPIR AS

Gry Egenes
Robert Adams, Maureen Baird, Jim Bengston, Richard Benson,
Deborah Bell, Inger and Lars Baald, Carole Kismaric, Susan Kismaric,
Ole Christian Magneshaugen, Lars Pettersen
AND  Holly Solomon

DAG ALVENG

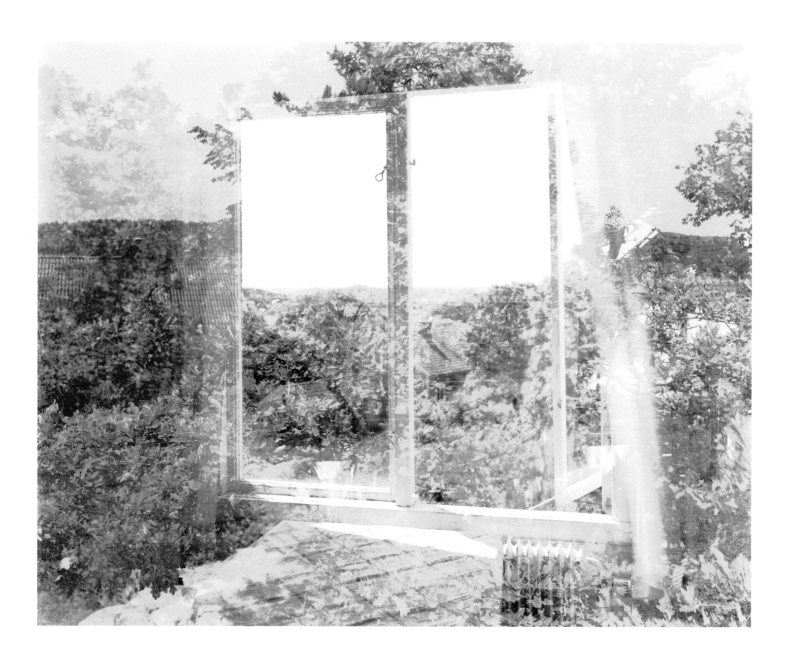